BLACK AMERICA SERIES

BEREA
AND MADISON COUNTY

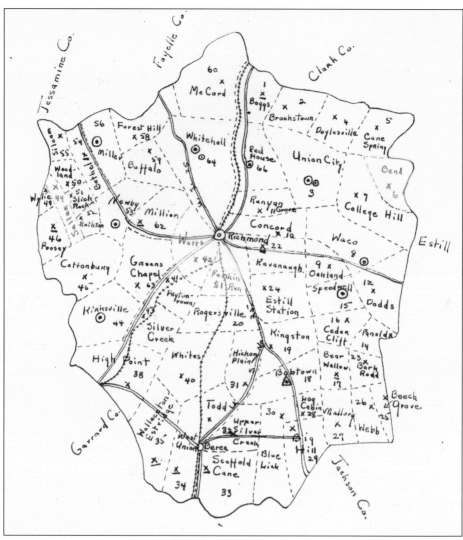

County school districts are outlined on this 1930 map of Madison County, which shows state highways U.S. 25 and 421, plus the Louisville and Nashville Railroad. Since Berea College and Berea city had formed an independent district, their graded schools are not marked. While each of the 66 districts had a school for white students, schools for black students had been consolidated from 24 to 14 by 1930. Above, senior high schools are represented by a circle with a dot, junior high schools are represented by a triangle with a dot, elementary schools with two teachers are shown with an X, and districts with no symbol had one classroom with one teacher. (Courtesy Jesse Ward/Robert E. Little.)

ON THE FRONT COVER: Those who had known abolitionist John G. Fee pose by a monument on the pre–Civil War site of the Glade Church that was supported by antislavery politician Cassius M. Clay. This monument can be seen near the office of Clay-Fee Homes Public Housing on Morgan Street in Berea, Kentucky. (Courtesy Berea College.)

ON THE BACK COVER: These Berea College students are studying drafting. Along with their general studies of grammar, history, arithmetic, and science, students could acquire applied skills. (Courtesy Berea College.)

For: Lucian + Josephine Martin Dillingham
Class of 1952.

Please enjoy in good Health!

BLACK AMERICA SERIES

BEREA
AND MADISON COUNTY

Jackie G. Burnside

Jacqueline Grisby Burnside

July 21, 2007

ARCADIA
PUBLISHING

Published by Arcadia Publishing
Charleston SC, Chicago IL, Portsmouth NH, San Francisco CA

Printed in the United States of America

Library of Congress Catalog Card Number: 2006940204

For all general information contact Arcadia Publishing at:
Telephone 843-853-2070
Fax 843-853-0044
E-mail sales@arcadiapublishing.com
For customer service and orders:
Toll-Free 1-888-313-2665

Visit us on the Internet at www.arcadiapublishing.com

To Virgil M. Burnside Jr., Berea's second African American citizen elected to the city council since the town's incorporation in 1890, when A. W. Titus was elected. I am thankful for all your support, which has helped to make this dream come true.
To Rachel B. Burnside, daughter and budding photographer, who accompanied me on several visits to collect information. I enjoyed your company and appreciated your patience.
To Nikki, Javonna, and Jasmine, daughters of Joyce Clay, who already are sowing "seeds" to help educate future generations, I am grateful.
To the memory of friends who helped with our earlier Historic Black Berea Projects but did not live to see the book completed: Marjorie Farris White, Helen Liz Menifee, Edgar Bernaugh, Geneva Pearl Broaddus Ross, Paul Dunson, Alonzo Ballard, Mitchell Ballard, Myrtle Ballard, Lena Mae Blythe, Harry and Jerri Miller Broaddus, Amanda Walker, and Warren Lambert.

CONTENTS

ACKNOWLEDGMENTS

This has been a project that benefited greatly from divine help and inspiration, and I am grateful. A very special thanks goes to Joyce Clay, whose faithful assistance at all hours during the week and on weekends was invaluable. Special thanks to Rita Mackin Fox, who not only directed me to Arcadia Publishing but also shared her editorial experiences so generously, and to Kendra Allen at Arcadia, who has been a good supporter. Special gratitude to Marcella Miller Matthews, who kept asking over recent years when the book would get written and for sending so many good resources my way. Special thanks to Berea College archivist Shannon Wilson for sharing his knowledge in selecting campus photographs from the Berea College Special Collections and his student worker, who scanned the images.

Additional thanks goes to Historic Black Berea Project Committee members, my sociology students, and community participants who have collected information over the years and who were steadfast in offering help recently: Andrew Baskin, Roberta Cornelison, Ruth Kennedy, Elizabeth Ballard Denney, David Miller, Odessa Joyce Boggs Denny, Gail Kennedy, Eastern Kentucky University Archives and Jackie Couture, Paul and Ruth Ferrell, the Richmond High School Alumni Association, Bonnie Mitchell, Sharyn Richards Miller, Jesse Ward, Pat and Ann Wilson, Nicole Harris of the Kentucky African American Heritage Commission, deans John Bolin and Stephanie Browner for support from the Berea College Faculty Development program, Janice Burdette Blythe, Belle Jackson of Berea Tourism, Regina Washington, Linda Kuhlman, and consultant Janet White Sikes (Atlanta, Georgia). Please communicate with the author about mistakes and omissions.

INTRODUCTION

Berea is a small city with a population of 9,851, based on the 2000 U.S. Census. Its black and white pioneers established an interracial community with a nonsectarian church (1855) and a coeducational school (1855), which quickly admitted black students after the Civil War ended (1866) to became an interracial institution. This community existed for nearly four decades until the State of Kentucky passed the Day Law of 1904, which required Berea College to segregate. Berea College had been the only higher education institution in the South to educate black men and women with white men and women for such a long time.

Descendants of some of these black and white settlers still live in and near Berea, and they have shared aspects of their families' history in photographs and images for this book. Located in the southern part of Madison County, Berea and four of the rural neighborhoods in its vicinity are featured—Middletown, Farristown, Bobtown, and Peytontown, along with selected sites in Richmond, Kentucky (Madison's county seat of government). Madison County lies in the central part of Kentucky, adjacent to Fayette County (Lexington) to the north, Garrard County (Lancaster) to the west, Rockcastle County to the south, and Jackson County to the east.

This book's focus is the nearly 40-year development of an interracial community based on the religious principle of the kinship (Christian brotherhood) of all people, especially between whites and blacks in a former slaveholding state after the Civil War. The economic and social life of this small town, and some of its surrounding neighborhoods, revolved around Berea College, which educated black and white students together from 1866 to 1904. The 1870 U.S. Census provides an estimate about the number of people in Madison County after the Civil War. Of the 19,543 people in the county, about one-third, or 6,272, were African American. Berea was part of the Glades census district, and of its 2,181 residents, about one-fourth, or 568 people, were African American. Richmond's population of 3,046, however, was nearly one-half African American (1,509 residents) and one-half white (1,537 residents). Violent clashes occurred between former slavery supporters, the freed people, and other citizens who wanted a fair and peaceful adjustment to the country's political and economic changes.

Berea's brotherhood model as a basis for society had been fairly successful for nearly 40 years when Kentucky legislators in Frankfort passed state representative Carl Day's bill to prohibit interracial education in 1904. The Day Law was designed to force Berea College to segregate. While pursing its case on appeals up to the U.S. Supreme Court, Berea College decided to keep its white students and fund its black students to attend all-black colleges in other places. After losing the Supreme Court case in 1908, Berea College's president and

trustees eventually raised more than $400,000 to buy more than 400 acres of land to build a new school similar to Berea College for black students. In 1912, this new school, named the Lincoln Institute, opened near Shelbyville, some 30 miles from Louisville, a city containing Kentucky's largest population of black folks. While the Lincoln Institute became a prominent boarding high school for more than 50 years, it never grew into a college. It is important to note that Berea College, during the 19th century, had offered classes from primary levels through 12th grade; it continued to operate a boarding Foundation School (high school), with the collegiate departments, until the 1960s.

Interesting photographs and names of lesser-known people who were involved in the historically unique college and its nearby communities make this book an important supplement to significant published works already available. It supplies some of the missing pieces of Kentucky history about black pioneers to this area and their successful interracial cooperation with their white neighbors.

After Kentucky legislators amended the Day Law in 1950, Berea College resumed admitting black students, though only a few enrolled each year until the late 1960s. Some city and county businesses were slow in welcoming larger numbers of students. By 2000, enrollments at Berea College tended to average 12 to 16 percent African American students out of a total enrollment of about 1,500 students. Campus life activities, work study environments, and the general education curricula were designed to convey the pioneers' recognition of the need for a practical application of the creed "that God hath made of one blood all peoples of the earth." Nationwide, America continues to face problems that reflect the historic racial injustices that formed the institutional foundations of the country's legal, economic, and social customs.

As these photographs will show, several aspects of Berea, the college and the town, in the late 1800s were probably 100 years ahead of the rest of the United States and quite successful in creating equal educational and economic opportunities for black and white people who shared common needs. Many people who experienced the "joy of Berea," as pioneer Sarah Ballard described life during that interracial period, went forth to share their enlightenment with others. In this book, some are still sharing their stories.

KEY TO PHOTOGRAPH CONTRIBUTORS

Linda Ballard, Berea, Kentucky.
Patricia Ballard, Farristown, Kentucky.
Berea College Archives and Special Collection, Berea, Kentucky.
Prof. Robert Blythe Middletown School Collection, First Baptist Church at Middletown, Berea, Kentucky.
Bobbie Herd Boggs.
Joyce Clay, Berea, Kentucky.
Dr. Joan Cobb, Columbia, Maryland.
Roberta Walker Cornelison, Bobtown, Kentucky.
Lovely Bernice Doe Baxter, Richmond, Kentucky.
Elizabeth Ballard Denney, Berea, Kentucky.
Hayden Ervine Dudley, Richmond, Kentucky.
Eastern Kentucky University Archives, Richmond, Kentucky.
Paul and Ruth Ferrell, Richmond, Kentucky.
First Baptist Church, Richmond, Kentucky.
Darlene Moran Henderson, Dayton, Ohio.
Melvin Higgins, Berea, Kentucky.
Robert "Bobby" Himes, Berea, Kentucky.
Gail Kennedy, Berea, Kentucky.
Ruth Rice Kennedy, Berea, Kentucky.
Marcella Miller Matthews, Berea, Kentucky.
David Miller, Peytontown, Kentucky.
Dorothy White Miller, Richmond, Kentucky.
Donald Pennington, Berea, Kentucky.
Richmond High School (RHS) Alumni Association c/o Paul and Ruth Ferrell.
James Preston Seals, Farristown, Kentucky.
Jesse Ward, Richmond, Kentucky.
Palestine "Pat" and Ann Wilson, Berea, Kentucky.

Selected Bibliography

The Berea Citizen. Microfilm, Hutchins Library, Berea College.

Boyce, Robert Piper. *Building a College: an Architectural History of Berea College*. Berea, KY: Berea College Press, 2006.

Burnside, Jacqueline G. *Philanthropists and Politicians: A Sociological Profile of Berea College, 1855–1908*. dissertation, Yale University, 1988.

Drake, Richard B. *One in Spirit: the Liberal Evangelical Witness of Union Church, Berea, Kentucky, 1853–2003*. Berea, KY: The Church of Christ, 2003.

Ellis, William E., H. E. Everman, and Richard D. Sears. *Madison County: 200 Years in Retrospect*. Richmond, KY: Madison County Historical Society, 1985.

Hayek, Doris Burgess. "Disaster Strikes: The Paint Lick Flood of 1913." *Paint Lick Reflections* Vol. 1 No. 4 (Winter 2003): 27–29.

Historical Register of the Officers and Students of Berea College from the Beginning to 1904. Berea, KY: Berea College Press, 1904.

Little, Robert E. *History of Education in Madison County*. Berea, KY: University of Kentucky, 1933.

Miller, Sharyn Richards, and Mary T. Richards. *The Family History: Second Blythe Reunion*. August 3–5, 1979, Berea, Kentucky.

Peck, Elisabeth S., and Emily Ann Smith. *Berea's First 125 Years, 1855–1980*. Lexington, KY: University Press of Kentucky, 1982.

Richmond Register, Richmond, Kentucky.

Sears, Richard. *The Day of Small Things: Abolitionism in the Midst of Slavery, Berea, Kentucky, 1854–1864*. Lanham, MD: University Press of America, 1986.

——— *Berea Connections: An Encyclopedia of Genealogy and Local History Related to Berea, Kentucky from 1854 to 1900*. Richard Sears, 1996.

———. *Camp Nelson, Kentucky: A Civil War History*. Lexington, KY: University Press of Kentucky, 2002.

Vockery, Bill and Kathy. *1870 Federal Census of Madison County, Kentucky*. Richmond, KY: Bill and Kathy Vockery, 1994.

Wilson, Shannon H. *Berea College: An Illustrated History*. Lexington, KY: University Press of Kentucky, 2006.

One

SETTLERS, ANTISLAVERY MISSIONARIES, AND CIVIL WAR SOLDIERS

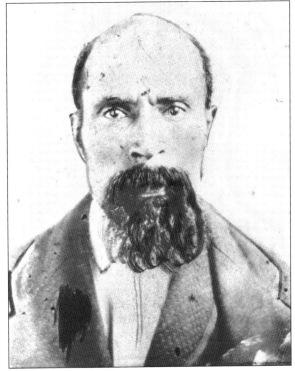

Born into slavery sometime during the mid- to late 1820s, Henry Ballard was known to be a strong-minded person whose back had been scarred with whippings. Invited by John Fee to come to Berea, Henry Ballard and his family were paid for their work helping to clear land and construct the early campus buildings. He bought land on Broadway Street North in Berea and on Walnut Meadow Creek, all in one tract, in 1882 for $35. (Courtesy Mitchell Ballard collection.)

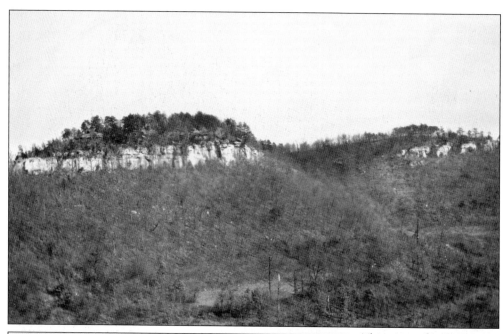

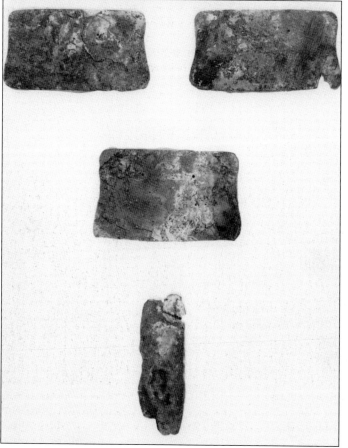

This view of Indian Fort, showing the south side, reveals the magnitude of the rock formations that the Native Americans found useful and beautiful. By the time Daniel Boone, one of the first white explorers, walked into this region, descendants of the earlier Hopewell culture had moved on. They left behind several burial mounds in the southern part of Madison County, one of which contained copper armor plates a high-level warrior or chief might have worn (seen left). As for Boone and his party, their fights with Shawnees and other tribal nations who shared the bounteous Kentucky River region hunting grounds were an ominous foreshadowing. (Courtesy Berea College.)

Author Harriett Beecher Stowe reportedly visited a slave cabin at the Kennedy plantation in Garrard County and drew inspiration from there for the characters and events in her novel *Uncle Tom's Cabin*. The site became a popular tourist destination for Berea College's visitors who had read Stowe's internationally popular book. Published in 1852, the book quickly sold 300,000 copies in the United States. When it was reprinted in 1892, it stimulated new tourists. (Courtesy Berea College.)

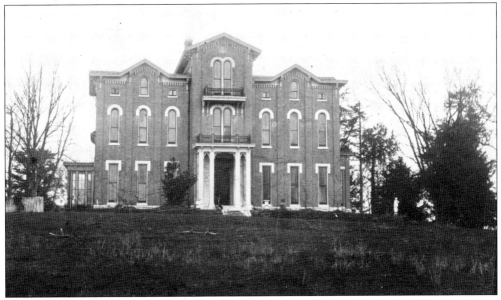

White Hall, the plantation home of Cassius Marcellus Clay, was constructed by his father, Green Clay. The elder Clay was a well-to-do pioneer whose Madison County property, by 1800, included 40,000 acres of farmland, slaves, gristmills, distilleries, taverns, and warehouses. (Courtesy Berea College.)

Cassius Marcellus Clay inherited his father's White Hall plantation, where approximately 90 slaves grew tobacco and corn, tended livestock, and performed other domestic labors. Politically ambitious, Clay held that slavery could be gradually ended through constitutional means. Seeking to build up a broad appeal among white antislavery constituents, he became an influential supporter of Fee's missionary work in Madison and nearby counties by 1855. (Courtesy Berea College.)

John G. Fee and his wife, Matilda Hamilton Fee, were two of Berea College's founders in 1855. Born into a slaveholding family in Bracken County, Fee became an abolitionist during his years at Lane Seminary (Cincinnati). After accepting an invitation to preach at an antislavery congregation in the Glade area of southern Madison County, he and Matilda later moved their family to settle on 10 acres of land given them by Cassius M. Clay. (Courtesy Berea College.)

Pictured here is an unidentified artist's drawing of the wooden building that was Reverend Fee's first church and the Glades Meeting House. Called to establish an antislavery church in 1853, Fee served as pastor of an antislavery congregation until 1859. That winter, the Fee family and several supporters were forced out of Berea into exile by an armed mob of some 60 pro-slavery supporters who rode from Richmond. (Courtesy Berea College.)

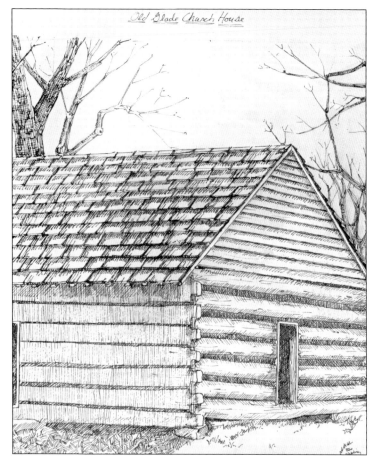

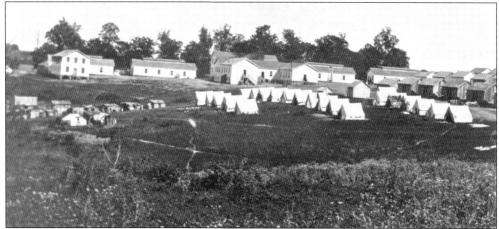

Kentucky had 23,703 African American soldiers serving in the Civil War, making it first among the loyal states. It ranked second among all 35 states for the highest number of African American troops; Louisiana was first with 24,052, and Tennessee was third with 20,133. Thousands of troops went through Camp Nelson (Jessamine County), one of the nation's largest recruitment and training centers for African America soldiers. (Courtesy Berea College/UK Photographic Archives.)

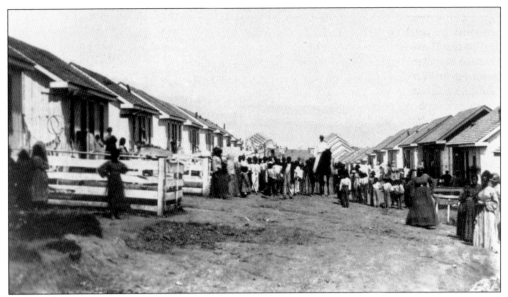

"Contraband" was the War Department's term for slaves seeking refuge in Union camps. Military policy ranged from protection with food and shelter to abandonment. Hundreds of soldiers' family members died from cold weather exposure when Gen. Speed Smith Fry ordered contrabands expelled from Camp Nelson during the severe winter of November 1864. After protests to the War Department, the cruel policy was rescinded. (Courtesy Berea College/UK Photographic Archives.)

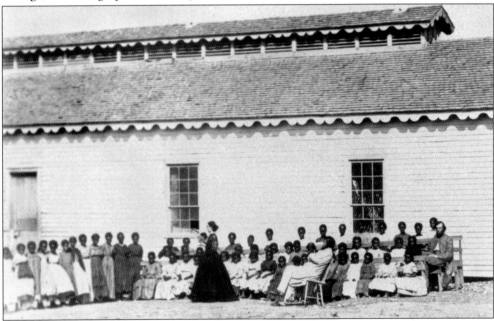

At Camp Nelson, Rev. John Fee instituted a school for noncommissioned soldiers, including the African American troops who needed to "write their names and muster rolls." Supported by the American Missionary Association who sent and paid salaries for teachers, Fee and other abolitionists were a godsend to the thousands of former slaves. The teacher in this photograph is being observed by two male visitors. (Courtesy Berea College/UK Photographic Archives.)

Born into slavery in 1830 and sold at age seven to Ferguson Moore, Elzira "Elzy" remained enslaved in 1865 after the Civil War. Fee arranged for Elzira, with two of her children, to travel with a slave group being guarded by his white friend Frank Bland to Camp Nelson to obtain "Free Papers." President Lincoln's 1861 Emancipation Proclamation had not freed slaves in Kentucky, a loyal slave state. (Courtesy Elizabeth Denney.)

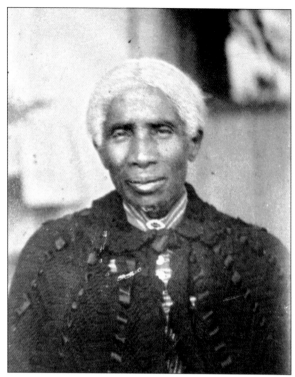

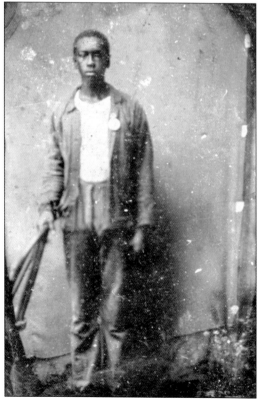

Reproduced from a tintype, this image of a young man dates from the late 1860s. He is not identified, but a round tag appears to be pinned to his shirt jacket. This picture came from a family's collection in the Peytontown community. (Courtesy David Miller.)

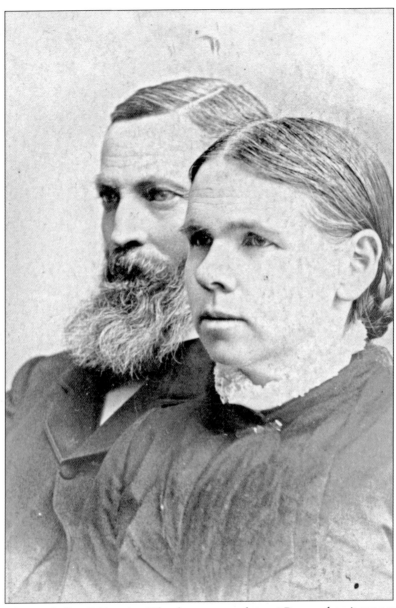

Rev. Willard W. and Ellen P. Topping Wheeler were teachers at Berea when it reopened in the spring of 1866 to be a school for all people of good character. An Oberlin College graduate, Reverend Wheeler worked with Fee at Camp Nelson. While the Wheelers were in Lexington on college business in 1871, Reverend Wheeler was ambushed and shot but managed to return to his hotel room to his wife. Later that night, masked men broke into Wheeler's room, dragged the reverend away, and whipped him 61 lashes with a hickory whip. His family recalled that Wheeler's lacerated back carried scarred ridges forever. In 1871, African American citizens in Frankfort and the vicinity sent a petition to the 42nd Congress to appeal for help against the Ku Klux Klan and other night-riding terrorists. Their petition listed details about 64 acts of violence directed against African Americans and white Republicans. For Madison County, seven violent acts of whippings and shootings, as well as two mob hangings in Richmond, had occurred between July and December 1869. (Courtesy Berea College.)

Julia Amanda Morehead Britton (from Franklin County) had been a musical child prodigy. Teaching instrumental music (piano) from 1870 to 1872, Britton became Berea College's first African American teacher. Britton and her siblings left Berea when their parents died within months of each other in 1874. Britton later married after moving to Memphis, Tennessee, and counted among her civic services the founding of a music school and an orphan and old folks home. (Courtesy Berea College.)

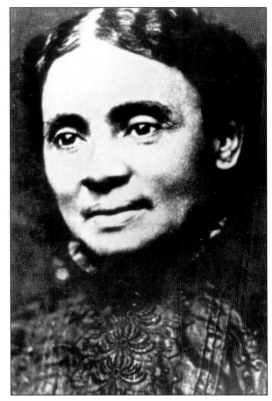

Angus A. Burleigh was among the first black students to enroll in 1866. A Union army veteran, Sergeant Burleigh served with Company G, 12th U.S. Colored Troops (Heavy Artillery). To pay expenses, he worked in the college's brickyard, hauling mud to make bricks for Ladies Hall. Burleigh graduated Berea College in 1875. After teaching in Indiana, he earned theology degrees and became the Illinois State Senate chaplain. (Courtesy Berea College.)

Katherine Gilbert was born in Massachusetts, but during the Civil War, she traveled south for the American Missionary Association (AMA) to teach freed people in Louisville (Jefferson County). One of her Louisville students, John Bate, worked to earn money to attend Berea College after Gilbert, his favorite teacher, departed the city. Gilbert joined the AMA workers at Berea College, where she taught German and English from 1870 to 1898. (Courtesy Berea College.)

John W. Bate became principal of Colored Schools and a respected educator in Danville (Boyle County). Born a slave on a Louisville plantation in 1855, Bate, his mother, and his younger siblings sought refuge in the city. Missionaries helped Bate get started in school where he met Prof. Kate Gilbert. He enrolled in Berea College in 1872 and graduated with a college degree in 1881. (Courtesy Berea College.)

Although not identified, this elderly man with the hat conveys a sense of determination to stand as straight as possible in this picture, despite the crooked angle seen at his hip. This photograph was among the collection from Peytontown, an area whose plantations covered thousands of acres worked by hundreds of slaves. (Courtesy David Miller.)

Initially called Church of Christ (Second), First Christian Church was organized in the home of Father Fee in October 1895. Fee donated the site where the original building has been remodeled and enlarged many times. In the belfry is the Freedmen's Bell, which Fee brought from Camp Nelson, where it had been used to summon freedmen to classes and religious services. (Courtesy Berea College.)

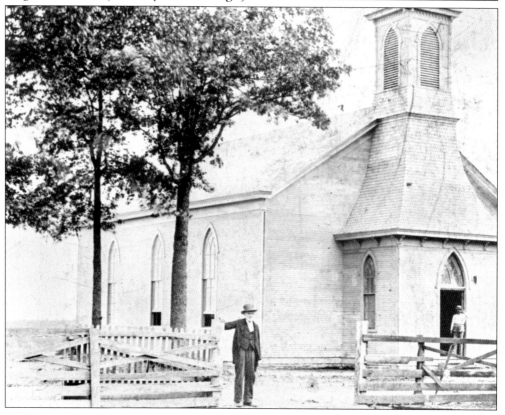

By 1874, Berea had 74 White families and 49 Black families were land owners. President John G. Fee helped provide black settlers with land of their own. This property was purchased from John G. Fee by Amanda White in 1891 for $50.00. The same property on Jefferson St. is now owned by her great-grand daughter and husband.

[Handwritten indenture document, 1891]

Amanda White bought a lot on Jefferson Street in Berea from John G. and Matilda Fee in 1891 for $50. It is still owned by White's descendants. As early as 1874, forty black and 74 white families were landowners. In areas nearby campus, blacks and whites owned housing lots adjacent to each other in a racially interspersed design that Fee believed would encourage "Christian brotherhood" between neighbors. (Courtesy Elizabeth Denney.)

The Doe children hold rabbits at their Center Street home. Robert Barton Doe (Barnwell, South Carolina) attended Berea from 1889 to 1895 (Academy I) and married Ella LaForte Estill (Richmond, Kentucky). He said, "At night we children would sit on the large front porch and look at the stars. My daddy would explain the different stars; we would watch for falling stars, and maybe see a rabbit come through running." (Courtesy Bernice Baxter.)

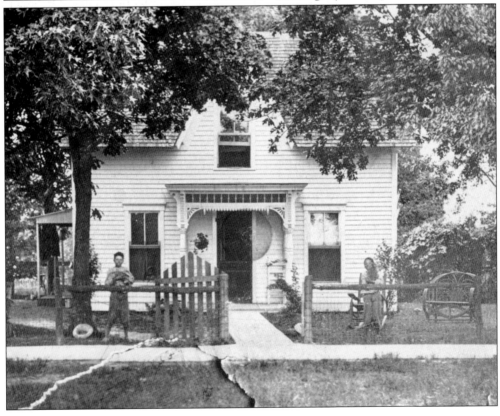

Two

INTERRACIAL EDUCATION

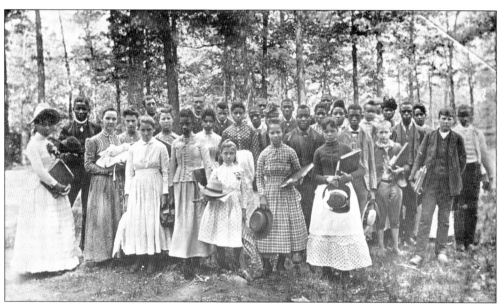

This group photograph, *c.* 1887, is thought to be the earliest taken of black and white, male and female students. Any person of good character, regardless of color, religious sect, or social class, could enroll in the Berea Literary Institute and progress through the Primary, Intermediate, and Grammar Departments of the academy and into the college courses to obtain a degree. Although unidentified, students in this photograph represent children and grandchildren of former slave families like the Ballards, Millers, Dudleys, and Crawfords, of longtime Madison County residents like the Rawlings and Burnams, of mountaineer newcomers like the Prestons, and of the school's founders like the Hansons, the Fees, and Dodges, to list a few. (Courtesy Berea College.)

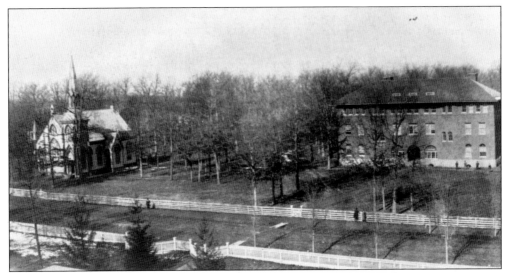

In 1880, Gothic Chapel (left) replaced the 300-seat wooden chapel that had burned in 1878. Gothic Chapel burned in 1902 and was replaced by the brick Phelps Stokes Chapel. Funds for Lincoln Hall (right) were donated by *Century Magazine*'s Roswell Smith, who was impressed by the school while attending the 1885 Berea College commencement. (Courtesy Berea College.)

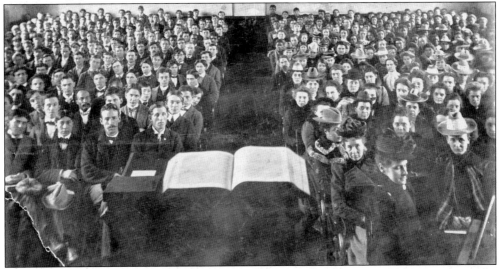

Inside Gothic Chapel, Berea College students, employees, and many town residents worshipped as one interracial congregation under Reverend Fee. Identified are Mrs. Lodwick (at organ); Margaret Wallace (to the right of the organ); Hallie Fee Embree, Reverend Fee's granddaughter (behind Lodwick next to the aisle); Frances Schultz (fourth row, fifth from aisle); (fifth row, from left to right) Laura Spence, Emma Spence, ? Lake, and Isabella Williams; (sixth row) Minnie Lake and Laura Washburn (fifth from aisle); (seventh row, from the aisle) Bess Flannery (second) and Minnie Todd (third); (eighth row) Carrie Spence (second from aisle); (ninth row, from the aisle) Dooley Welch (second), Edity Early (third), and Etta Lewis (fourth); (10th row, from the aisle) Dinksis Lake (first), Ollie Blanton (third), Maud Lake (fourth), Martha Lake (fifth), and (wearing the hat) Mary Alice Titus (Alfred Walker Titus's daughter). (Courtesy Berea College.)

Elgetha Brand was a first-generation Southern black person born into freedom in 1867. Her parents came out of slavery with nothing, so she worked and studied for six years at Berea but did not graduate because of poor finances. Returning to Winchester (Clark County) to teach, she married George Bell, an 1892 graduate, and they settled in Middlesboro (Bell County). He taught and later became principal of Colored Schools. (Courtesy Berea College.)

Berea College students use the library in Lincoln Hall, a "Recitation Hall" with 18 rooms, for classrooms, offices, laboratories, and a museum. Roswell Smith, founder of *Century Magazine* (New York) and donor of almost all of the $32,000 used to build the hall, did not want it named after himself but for Abraham Lincoln. In 1887, Smith sent a bronze bas-relief of Abraham Lincoln sculptured by J. S. Hartley to the college. (Courtesy Berea College.)

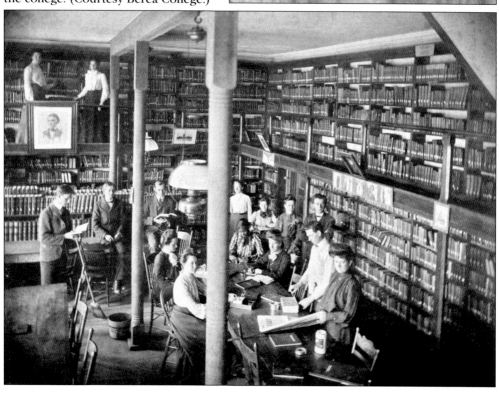

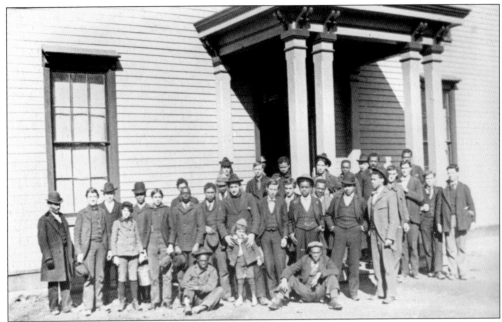

Male students from various classes pose in front of Howard Hall during the spring of 1891. Howard Hall, a three-story, wood-framed structure that accommodated 82 young men, was built with a gift of $18,000 from the Freedmen's Bureau based on former Civil War general Otis O. Howard's recommendation. (Courtesy Berea College.)

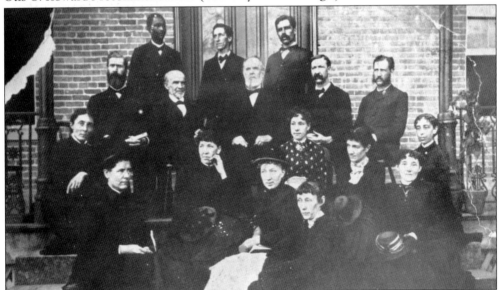

Pictured standing from left to right are James S. Hathaway, an African American, and Pres. William G. Frost. From Mount Sterling, Hathaway was an 1884 alumnus (A.M. 1891) who taught Latin and mathematics for 10 years. Later President Frost supported the faculty's recommendation that Hathaway be denied a promotion, whereupon Hathaway resigned, accepted a professorship, and subsequently became president of the Kentucky State Normal College (Franklin County). Seated in front of Hathaway and Frost is Rev. John Fee. (Courtesy Berea College.)

Though unidentified, these ladies represent the first wave of young adults who could aspire to higher education within a few years after slavery ended. Under slavery, Kentucky's laws prohibited the education of slaves, and it was not unusual, between 1869 and 1886, for students aged 16 to 18 years to be enrolled in primary grades. (Courtesy Berea College.)

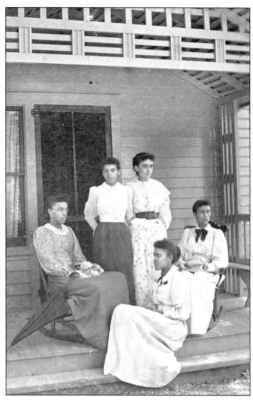

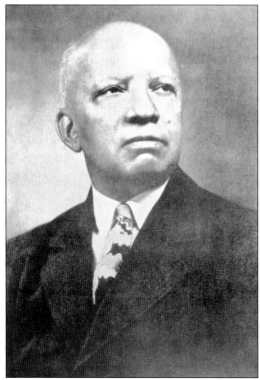

Carter G. Woodson's parents, James Woodson and Anne Eliza Riddle, had been slaves, but he studied and worked at Berea College, graduating in 1903. For a brief period, Woodson taught and was principal of Colored Schools in Huntington, West Virginia. He obtained a Ph.D. from Harvard in 1912. He traveled and studied internationally, becoming a famous historian, author, and founder of Black History Week (Month). (Courtesy Berea College.)

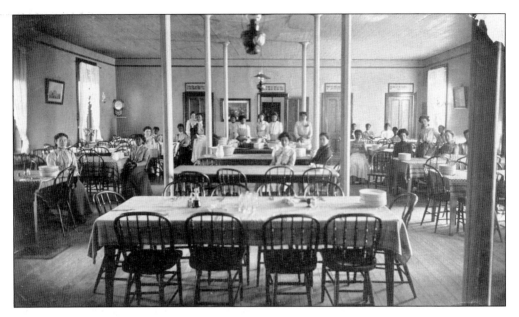

Ladies Hall (now Fairchild Hall) contained the dining room where matrons oversaw students' table manners. One interracial group at Matron Ella Swezey's table in 1897 (below) was Will D. Candee (1), Gertrude Candee (2), Thomas L. Routt (3), John Barton, (4), D. E. Dobbins (5), Ella J. Swezey (6), Adelia Fox (7), R. P. Lyman (8), Merlie Wiltsie (9), Vena Allen (10), Grace H. Barton (11), Ira L. McLaren (12), and J. Louise Maltbie (13). The Candees were brother and sister whose abolitionist father, Rev. George Candee, advocated Berea's interracial school be founded in Jackson County, not Madison. Grace Barton married Ira McLaren in 1900. Thomas Routt, an African American from Bath County, became a Congregational preacher in Alabama after graduation from Berea (1897) and Atlanta Theological Seminary. Ella Swezey married and lived in Hollywood, California. (Courtesy Berea College.)

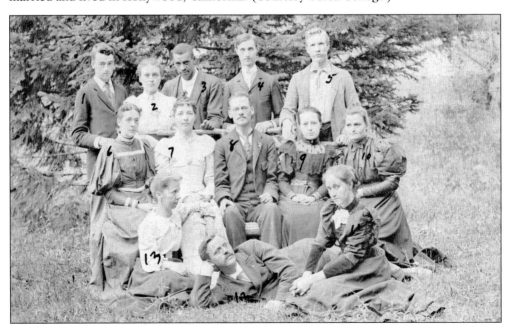

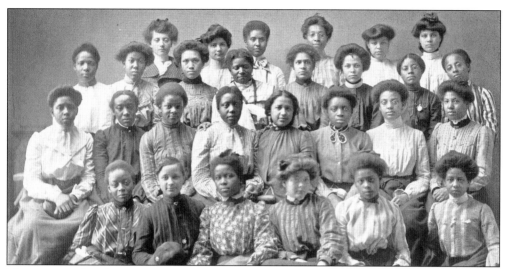

These young female students are not identified, but their photograph may have been taken around 1899. Some family names of students during that period were Berry of Kirksville or Rockhold (Whitley County); White and Miller of Berea, Peytontown, or Richmond; Overstreet of Camp Nelson (Jessamine County); Simpson of White's Station; Walker of Berea, Lowell (Garrard County), and Richmond; and Young of Harrodsburg (Mercer County) and Lexington (Fayette County). (Courtesy Berea College.)

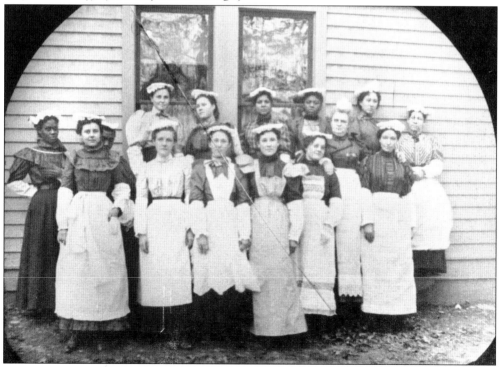

Pictured here are women students from the Domestic Science program. This was one of the college's vocational education programs aimed at providing practical training for students. Other programs included the normal course for teacher training (started in 1867), farm economy (1891), and nurse training (1899). (Courtesy Berea College.)

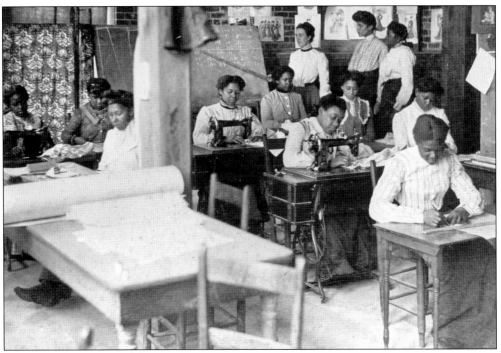

Young women are learning to sew and operate the sewing machines. At home, many students probably learned to sew by hand. Having an opportunity at school to use a sewing machine would have been a modern treat. (Courtesy Berea College.)

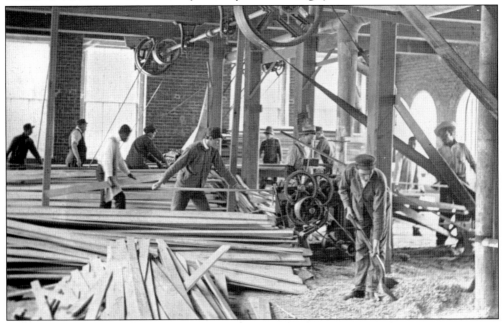

Berea students are preparing lumber in the carpentry shop in the woodworking building. Students could gain practical training in an industrial trade such as carpentry, in addition to earning income to help support their education. Carpentry was one of several vocational education courses available to students by 1898. (Courtesy Berea College.)

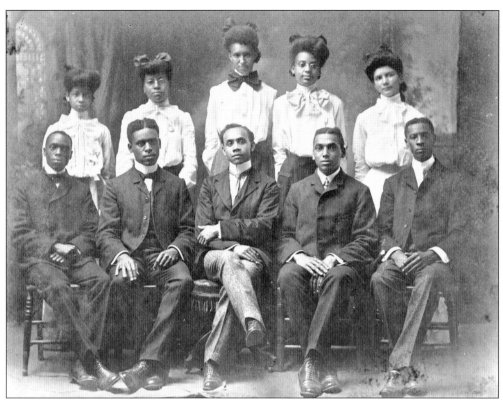

During the early years of President Frost's tenure, he arranged for photographs to be taken of students grouped several ways—by race and gender (both separate and together), by region of origin (such as Kentucky counties), or by the states they represented to show the college was educating students from both the North and the South to "efface (erase) sectional lines." The interracial group below, standing on the steps of Ladies Hall, is from Ohio. For most groups, students' names were not captured along with their images, which is the situation for both photographs here. (Courtesy Berea College.)

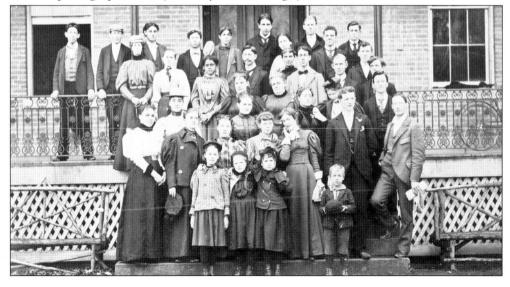

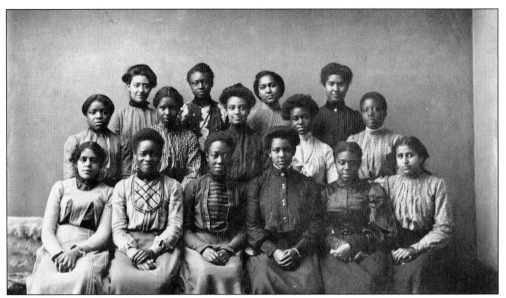

African American students described as mulatto, or mixed race, were substantial among Berea's enrollment. Even the 1870 U.S. Census for Madison County listed numerous persons in its mulatto racial category. Slave owners' sexual exploitation of slave women produced generations of light-complexioned people over the centuries. Visiting Berea's 1884 commencement, George Washington Cable, a New Orleans author, was impressed with the interracial education but curious about social equality of interracial dating and marriage. (Courtesy Berea College.)

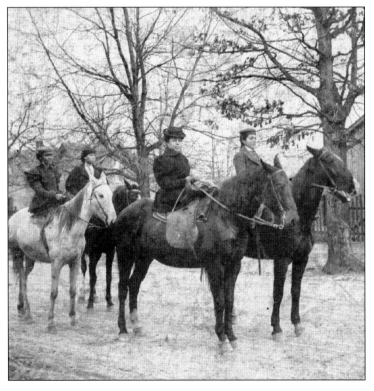

Four Berea students, mounted sidesaddle on horses, prepare for a ride. Only Bessie Pollard (foreground, right) is identified, riding the dark horse with the light-colored nose. Bessie came from Paint Lick (Garrard County) and attended Berea from 1900 to 1902. Her courses included reading, spelling, arithmetic, geography, drawing, cooking, and serving. Bessie later married John Wesley Cobb of Richmond, a veteran of the Spanish-American War. (Courtesy Joan Cobb.)

JAS. BOND,
Minister, Nashville, Tenn.

M. H. JACKSON,
Prin. Mo. State Normal.

W. C. TAYLOR,
Prin. Manassas
Industrial School.

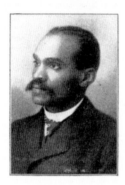

GREEN P. RUSSELL,
Supt. Lexington Col. S.

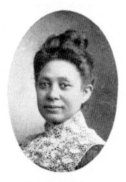

MARY E. BRITTON.
Physician.

F. S. WILLIAMS,
Prin. Covington H. S.

WALLACE A. BATTLE,
Prin. Okolona Indust.
School, Miss.

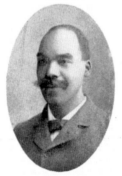

KIRKE SMITH,
Supt. Lebanon Col. S.

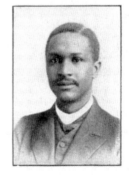

JAS. S. HATHAWAY.
Pres. Ky. State Normal.

COLORED GRADUATES.

Berea College's published register of 1904 featured "colored graduates." Rev. James Bond served as college trustee from 1896 to 1914 and helped raise money to build the Lincoln Institute. Mary E. Britton, a physician in Lexington, was Julia Britton's younger sister. Kirke Smith also raised money for Lincoln Institute, and he became a principal there. After leaving Berea College's faculty, Hathaway served as president of Kentucky State Normal College. (Courtesy Berea College.)

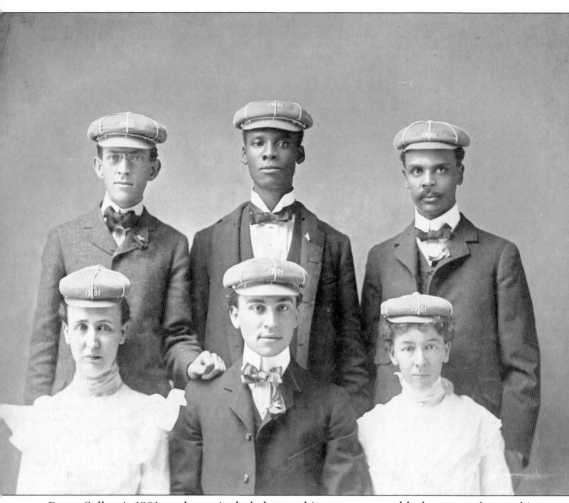

Berea College's 1901 graduates included two white women, two black men, and two white men. Pictured are, from left to right, (first row) Mary C. Hoopes, Frank Ewers, and Hallie Fee Embree; (second row) John C. Chapin, Wallace A. Battle, and Webster B. Beatty. In 1903, Mary Hoopes of Oberlin, Ohio, married Ernest G. Dodge, an 1893 Berea College graduate. Embree was a missionary to Argentina for a year before moving to California. Wallace Battle, from Alabama, taught at Anniston Normal College (Alabama) before founding and serving as president of Okolona Industrial College in Mississippi. Webster Beatty grew up working in the household of 1885 Berea College graduate Dr. William E. Barton and his wife, Esther Treat Bushnell Barton. They were very supportive of Beatty's pursuit of higher education, and in some college records, Beatty's middle name is recorded as Barton. After graduation from Berea, Beatty studied dentistry at Howard University in Washington, D.C., and at Northwestern University in Chicago, Illinois; he was a dentist in Cairo, Illinois. In 1906, Beatty married Alice Titus, a 1902 college graduate who became a public school teacher. (Courtesy Berea College.)

Written on the back of this photograph are the following students' names (possibly from left to right): Martha Adams, unidentified, ? Crawford, and unidentified. Records indicate that Martha A. Adams of Manchester (Clay County) was enrolled in Primary in 1877, in Academy I during 1886–1891, and was a trained nurse in Lexington by 1904. Rev. Anderson and Caroline Crawford's daughters were students and this may be Emma, Josephine, or Laura B. (Courtesy Berea College.)

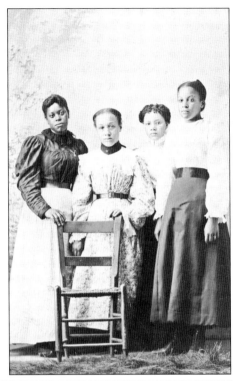

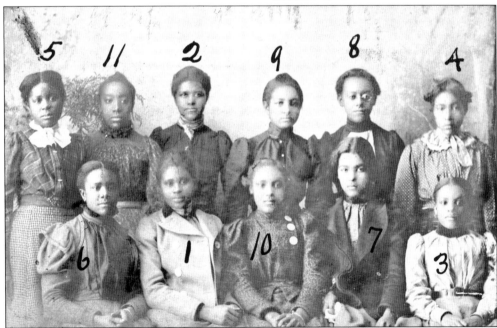

Notable among these young scholars are Mary Eliza Merritt (5) of Berea, who became a nurse; Ida Elizabeth Simpson (11) of White's Station, who attended Normal from 1900 to 1901; Allie M. Watts (2) of Peytontown, who attended Normal from 1900 to 1901; and Joella White (4) of Berea, who was in college preparatory by 1903. Joella later married Arthur J. Baxter of Farristown. These names were provided by Mrs. Bush. (Courtesy Berea College.)

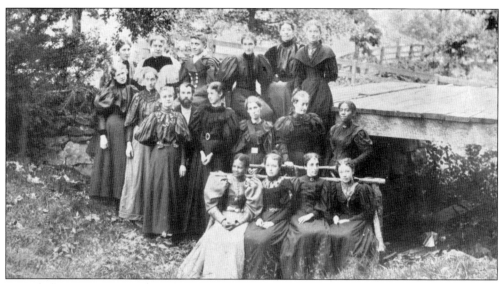

During the pre–Civil War activities of the Berea Literary Institute, Elizabeth Rogers, Berea's first teacher, used songs as one teaching technique to help her students remember their lessons. After the Civil War, Berea College's weekly schedule of lessons included morning devotions before classes started. Forming music groups like this Women's Glee Club served to help students improve their skills and provide cultural enjoyment. (Courtesy Berea College.)

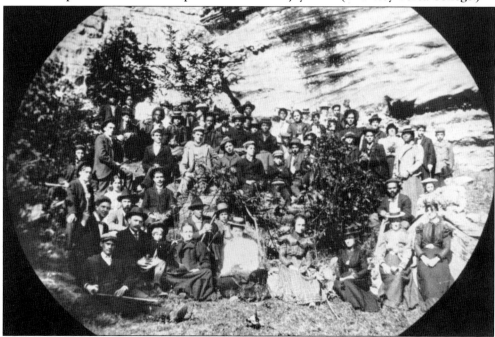

Robe's Mountain was a popular site for "wagon parties," and these students, with their faculty chaperones, are having an all-day picnic. Pres. E. Henry Fairchild led Berea College's first Mountain Day picnic in 1875. Berea College's forest and agricultural expert, Prof. Silas C. Mason, urged the purchase of nearby forests. By 1898, Mason had personally bought the East Pinnacle and Indian Fort mountain tracts until the college could raise the money to buy tracts from him. (Courtesy Berea College.)

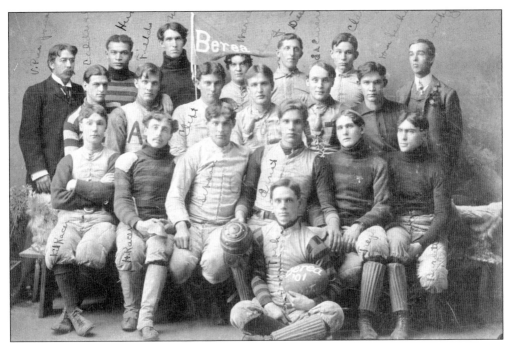

In 1901, Berea College had a intercollegiate football team, whose members included George Dick, a student who was later employed by the college to help develop its waterworks and sanitation system to serve not only the campus but also the town. One African American student on this team was William H. Humphrey of Maysville. After his 1903 graduation, Humphrey attained an A.M. degree at Harvard (1908). (Courtesy Berea College.)

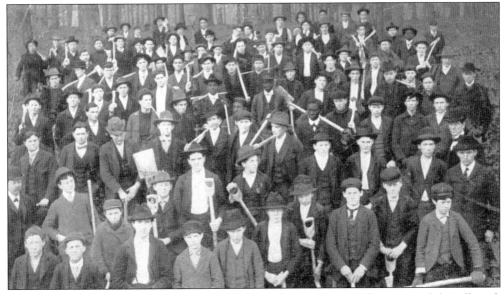

Students hold shovels and pickaxes to publicize to donors Berea College's creed that all work has dignity. Recognizing that students from freedmen and mountaineer families needed to work to pay for their education, college officials employed students for various tasks, including building construction. Also, foodstuff and other items were acceptable barter for tuition and book expenses. President Frost is on the third row at far right. (Courtesy Berea College.)

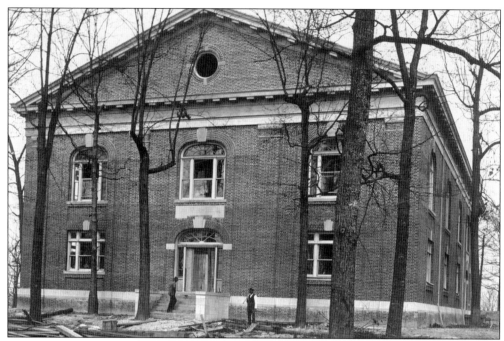

Under construction from 1904 to 1906, Phelps Stokes Chapel was built with student labor as the main donor, Olivia Phelps Stokes of New York, requested. She even gave money so students could build a men's industrial (woodworking) building in order to gain vocational skills to construct the chapel. Timbers came from the college's forest, and a third brickyard was constructed in 1901 at Rucker's Knob. (Courtesy Berea College.)

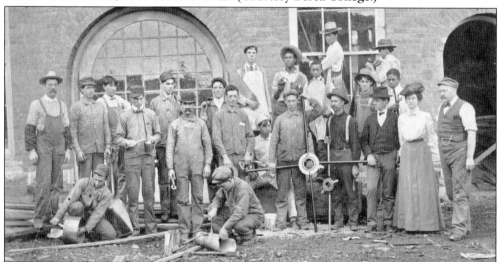

Based on George G. Dick's memory in 1955, pictured from left to right in front of the woodworking building in 1903 are (first row) unidentified (kneeling); Walter Robe; and unidentified (squatting); (second row) T. H. Horton, George G. Dick, two unidentified, Marion Chasteen, Stanley VanWinkle (seated), C. M. Canfield, Bert Coddington, A. Noah May, unidentified, and C. A. King; (third row) Raymond Osborne, Chester Grider (in cap), Arthur Hunt, Gilbert Combs (with saw), two "colored," Everett VanWinkle (at window), Burritt VanWinkle (at window side), and "colored."

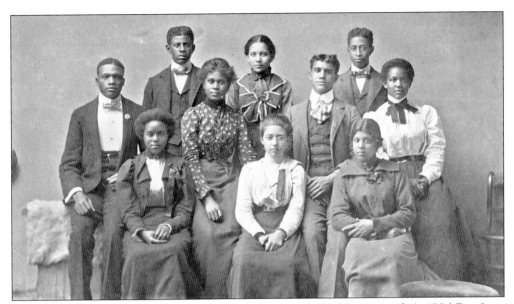

Some scholars' academy years at Berea College were halted by Kentucky's 1904 Day Law. Pictured are, from left to right, (first row) Zattie J. Hicks of May's Lick, Corinna Smih, and Marzonetta Grundy; (second row) William Meradia Tye of Rockhold (Whitley County), Frances Berry (later Mrs. George Coston), James King, and Madge B. Sutton of Danville (Boyle County); (third row) Henry Berry, Josephine Smith of Millersburg, and Thomas Berry of Rockhold. (Courtesy Berea College.)

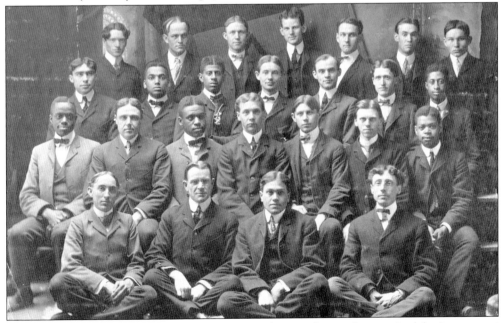

Phi Delta was a student organization whose members took great interest in debating current issues. Although not identified, members here illustrate the interracial nature of college life before the 1904 Day Law. As one white alumnus noted later, the white person who came to Berea College before 1904 soon realized that to have a "school life worthy of the name," they would be partners with black students. (Courtesy Berea College.)

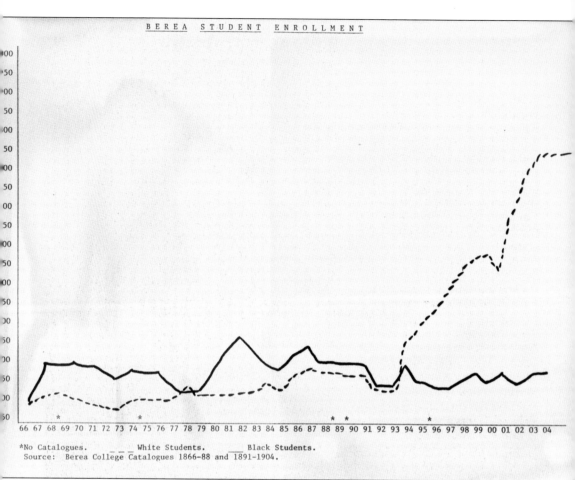

*No Catalogues. _ _ White Students. ___ Black Students.
Source: Berea College Catalogues 1866-88 and 1891-1904.

An enrollment graph summarizes the long-term trends of black and white students' attendance at Berea College from its 1866 enrollment of blacks to become an interracial institution to the fall of 1904 when the Day Law was enforced. For nearly all the years between 1866 and 1893, black enrollment exceeded white enrollment among the student body, which numbered around 400. As President Frost increased the size of the school by admitting white students from the Appalachian Mountains, his actions aroused suspicions among some black students and they wondered whether they were meant to stay included or not. President Frost hoped the new white students would give up their racial prejudices, but those students actually discovered they could create a school life without having much to do with their African American classmates. (Courtesy Berea College.)

40

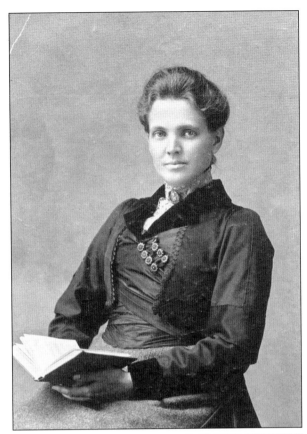

Eleanor Marsh Frost, President Frost's wife, encouraged the educational aspirations of African Americans. In early September 1904, the Day Law was enforced to prohibit interracial education at Berea College. Eleanor rode the train to Camp Nelson (Jessamine County) to persuade Sophia Overstreet's mother to let Sophia attend Fisk University using Berea's financial aid. By the day's end, a newly bought trunk was packed, directions were written down, and Sophia drove away in horse and buggy to Nashville, Tennessee. She later graduated from Fisk. In the students' photograph, Sophia's sister, Bessie Overstreet, who attended Knoxville College, stands fourth from the left on the second row. Other students are not identified. (Courtesy Berea College.)

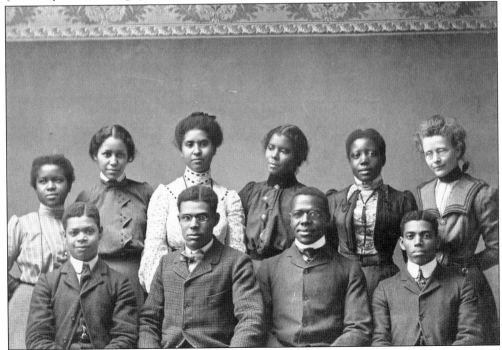

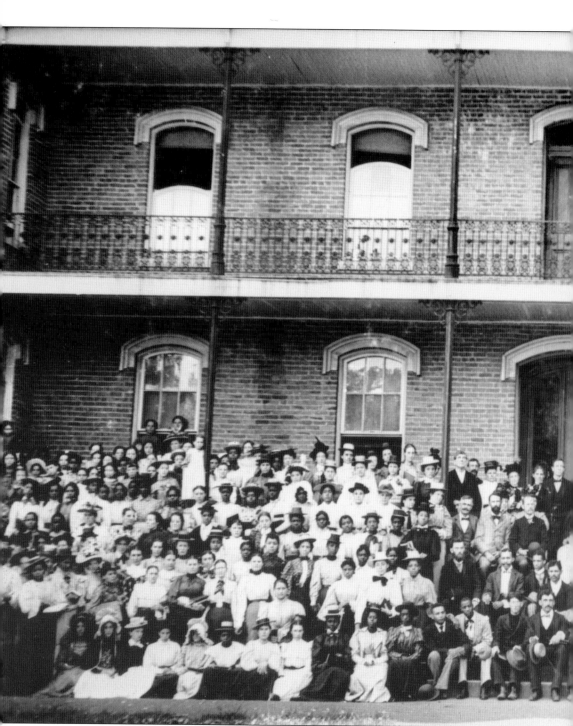

Taken around 1900, the entire student body of Berea College poses with the faculty. Although black and white students are interspersed in this photograph, black student enrollments did not keep pace with their white counterparts as the school's population began to grow under President Frost's leadership. These changes sparked controversies between many black, and some white, alumni who were suspicious that President Frost's actions were diminishing Berea's

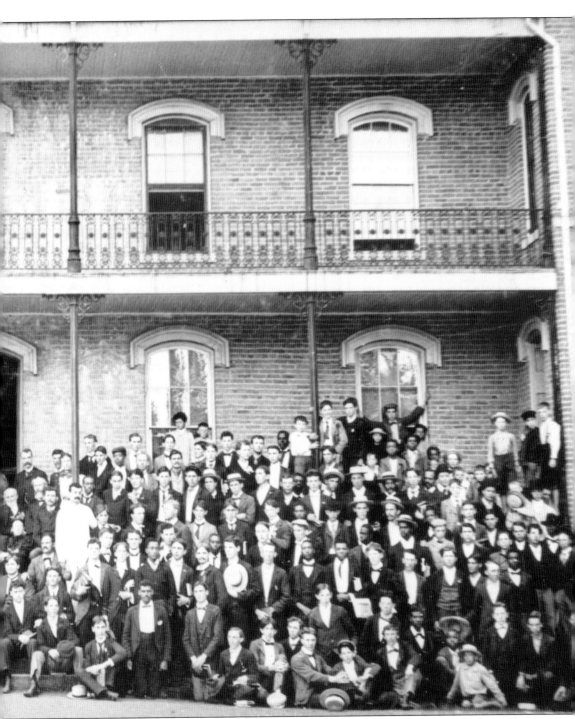

interracial equality. Seated at center on Ladies Hall's porch is college founder and president of its board of trustees, Rev. John G. Fee. This residence hall later was renamed Fairchild Hall in honor Julia Fairchild, the daughter of Edward Henry Fairchild, Berea College's first president. Standing at Fee's right side was Pres. William Goodell Frost. Reverend Fee died in January 1901; President Frost in September 1938. (Courtesy Berea College.)

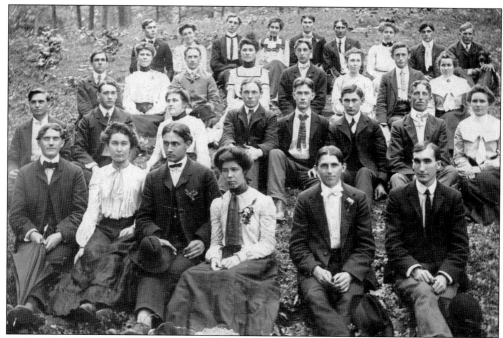

This photograph may have been taken after the 1904 Day Law. Included in this image are the following: (first row) ? Grigsby (far left), ? Picklesimer (third from left), and Taylor Gabbard (fifth from left); (second row) "Doc" Chandler (fifth from left) and Paul Dirthick (seventh from left); (third row) H. W. Combs (née Miss Haney, second from left), Malcolm Holiday (fifth from left), and John Creech (seventh from left); (fourth row) ? Howard (far left), Henry Combs (third from left), Etta Gay (Mary Etta/Marietta, fourth from left), and ? Fry (fifth from left). (Courtesy Berea College.)

One response to Kentucky's 1904 Day Law, which targeted Berea College's interracial education, was to send some former Berea College students to Knoxville College, aided financially by Berea College. Pictured from left to right are (first row) Zephyr Mays, Mable McElroy, Maggie Kavanaugh, Bessie Overstreet, Francis Woods, and Priscella Moran; (second row) Norman Williams, Enos Walker, Curtis Simpson, Mitchell Burnside, Lewis Simpson, and Milton Williams. (Courtesy Berea College.)

Three

INTERRACIAL LAND OWNERSHIP

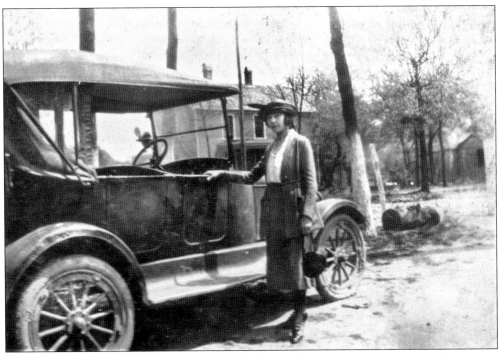

Annie Mae Doe is standing by the old Ford car that belonged to her mother, Ella Doe, in Berea. Annie became one of the growing numbers of African Americans who migrated north from small towns and rural areas in Kentucky during the 1920s. The mean-spirited effects of Kentucky's Day Law accelerated the outward migration trend for the black youth of Berea's historic families. (Courtesy Bernice Baxter.)

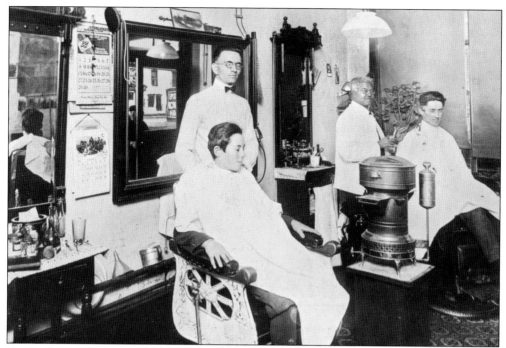

To pay for his education costs, Robert B. Doe became a barber and one of Berea's African American business owners. Doe (pictured standing at right) used stools before he could afford a barber chair and sometimes hired a white barber to assist with customers. He married Ella LaForte Estill of Richmond, and they reared their family on Center Street in Berea. (Courtesy Bernice Baxter.)

Special visitors to Berea College in the 1890s stayed in the president's house. However, President Frost's wife, Ellen, urged him to build a hotel, and Boone Tavern opened for business in 1909. Black businessman Robert B. Doe operated his barbershop in the hotel's basement for a few years. (Courtesy Berea College.)

46

From left to right, the Frost family members are Pres. William G. Frost, his wife, Eleanor "Ellen" Marsh Frost, and son Cleveland Cady Frost in his World War I uniform. When news came that Cleveland had been killed when his ship was attacked, Ellen telegraphed their beloved family friend, Mary Merritt, that Cleveland was lost. Mary had lived and worked in the Frosts' home while attending Berea Academy. (Courtesy Berea College.)

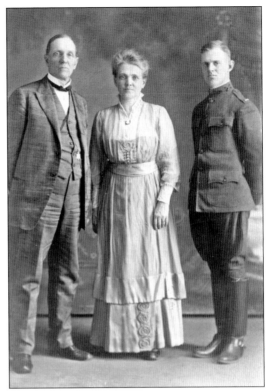

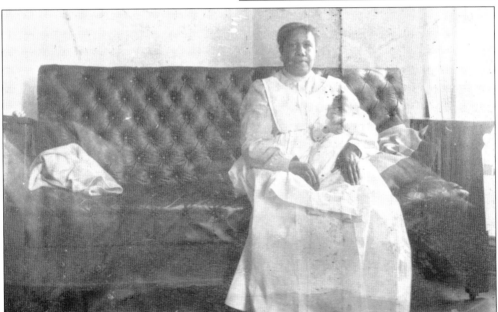

Mary Eliza Merritt of Berea graduated from Berea College's two-year nursing program in 1902 and completed the registered nurse program at Freedman's Hospital in Washington, D.C. Mary was a private nurse to retired politician Cassius M. Clay before becoming superintendent of Louisville's Red Cross Hospital in 1911. Under Mary's 34 years of leadership, the hospital grew from 12 beds to over 100, with modern equipment. (Courtesy Bernice Baxter.)

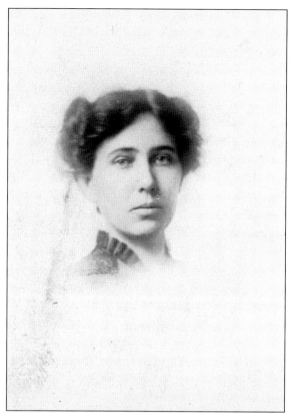

Margaret M. ("Maggie") Todd attended Berea's academy and married Absalom Golden in 1896. She enrolled in Berea's nursing program with African American classmates Maggie Jones (of Danville) and Mary Merritt (of Berea), all of whom completed the program as the class of 1902. Todd worked as assistant matron in 1899–1901 and, by 1913, was in charge of the Students' Coop Store. Often called to nurse homebound neighbors, Maggie died in 1924 and was missed by many people. (Courtesy Berea College.)

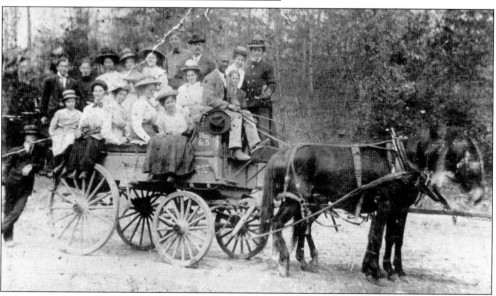

George Reynolds worked for Berea College as a mail carrier and also drove visitors from the train depot to campus and on trips through the hills. He got the job one morning when President Frost needed someone to look after the horses. Reynolds did such fine work that Frost gave him the job as long as he wanted, which turned out to be nearly 40 years. (Courtesy Berea College.)

Annie Mae, oldest of the Doe children, appears here with her good friend Amanda Moran, daughter of Edward and Elsie Hagan Moran. The Morans lived on the corner of Jefferson and Ellipse Streets across from campus westward, while the Does lived on Center Street, one block east of campus. Amanda attended Berea College's primary department before the 1904 Day Law segregation, but Annie was too young. (Courtesy Bernice Doe Baxter.)

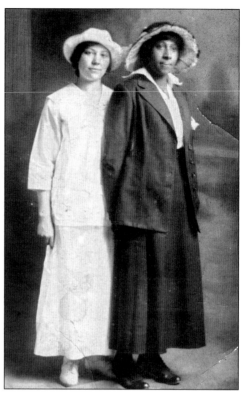

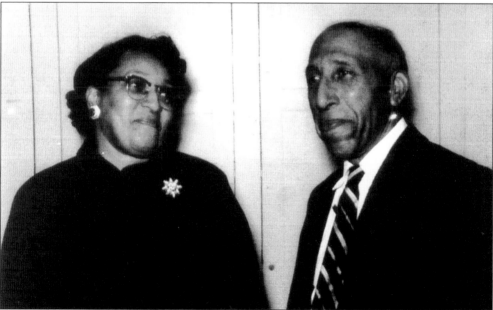

John Fee Moran and his wife, Adelia Moran, were active members of First Baptist Church in Middletown. Moran got his name when Reverend Fee asked his father, Ed Moran, the name of his new son and Moran answered that they had not decided. Reverend Fee asked Ed Moran to name the baby after him. John Fee Moran worked for Berea College, but the Day Law prevented his enrollment. (Courtesy Darlene Henderson.)

Willard Kennedy, son of Ashford and Fannie Route Kennedy in Berea, worked in Berea College's boarding hall before becoming a Pullman porter on the Louisville and Nashville and the Baltimore and Ohio Railroads. He married Aline Bush. Their children ran to the tracks when they heard his train, and as the train slowed, Kennedy would lean over to hand his children an envelope with his tip money. (Courtesy Gail Kennedy.)

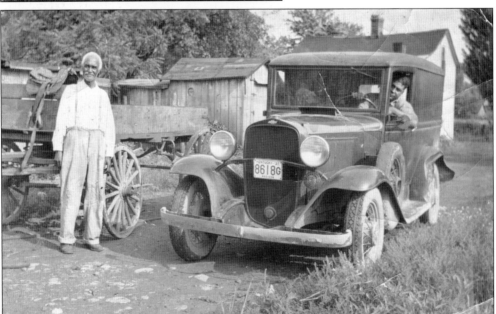

George Reynolds stands by the wagon he used as a mail carrier and driver of Berea College visitors; he retired after nearly 40 years. Reynolds and his wife, Amanda White, were married by Rev. John G. Fee and owned a home on the corner of Ellipse and Jefferson Streets, across from campus. Walker White Sr., Reynolds's replacement, sits in the first truck that Reynolds used in his carrier work. (Courtesy Elizabeth Denney.)

50

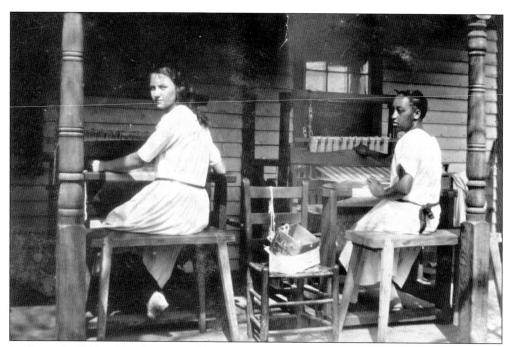

In the early 1920s, Glendon Reynolds (right) weaves at the Loom House of Mary A. Anderson, located on Jefferson Street, just a few doors from Reynolds's home. The other weaver is unidentified. Anderson was recognized as the "Dean of Weavers" in Berea. Reynolds once wove a coverlet that reportedly was for Mary McLeod Bethune, a well-known educator and special adviser to Pres. Franklin D. Roosevelt. (Courtesy Elizabeth Denney.)

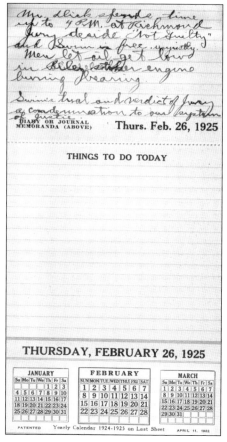

Berea College's power plant superintendent, George G. Dick, wrote of his disagreement with the Richmond jury's not guilty verdict in a 1925 campus tragedy. A 21-year-old white student, Hobart Swim of Frenchburg (or Hazard), fired four times to kill Roosevelt Ballard, a black employee of Berea College. An unarmed Ballard was killed by two of the shots. Ballard's wife, Glendon Reynolds Ballard, was pregnant with their daughter Elizabeth. (Courtesy Berea College.)

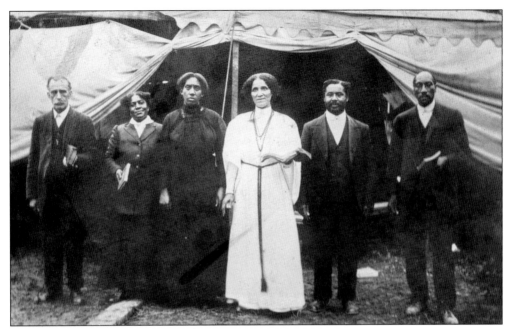

Conducting tent revivals in many central Kentucky communities, Mrs. Brown was a very dynamic preacher and drew large crowds. When she held her tent meetings in Berea, Ella Estill Doe would invite her to eat at the Doe family's house. In the photograph, Preacher Brown wears a white dress; others are not identified. (Courtesy Bernice Baxter.)

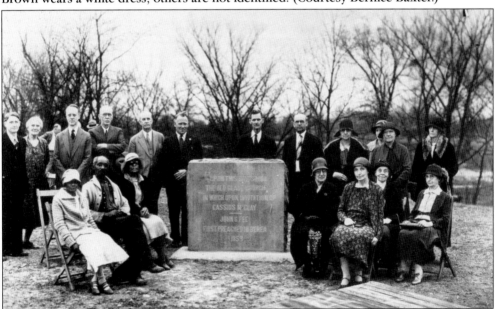

People who knew abolitionist John Fee pose by a monument site at the Glade Church, which was supported by antislavery politician Cassius M. Clay. Pictured from left to right are (first row) Lillie Ann Hollingsworth, Perry Rice, Julia B. Walker; two unidentified, Mrs. Fred F. Hall, and unidentified; (second row) George Dick, ? Merrow, Fred Fairchild (F. F.) Hall, ? Dizney, Edwin Fee, Pruitte Smith, ? Van Winkle, ? Durham, two unidentified, ? Pettit, and unidentified. (Courtesy Berea College.)

When Berea incorporated as a town in 1890, an interracial government was elected; city trustee Alfred W. (A. W.) Titus was African American. Pictured *c.* 1920 are, from left to right, Mayor John Lewis Gay, college treasurer Thomas J. Osborne, Pres. William J. Hutchins, and secretary Howard E. Taylor. The city and college collaborated on campus and city streets, sanitation, and buildings. Gay, Berea National Bank's president, served 48 years as the town's first mayor. (Courtesy Berea College.)

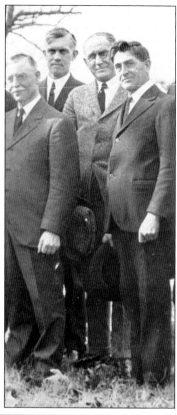

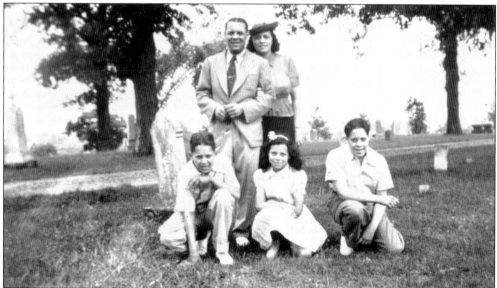

Kenneth Titus and his family, descendants of Alfred W. Titus, returned to visit local relatives. Buried in the Berea Cemetery are A. W. Titus's daughter Alice and her husband, Webster Barton Beatty. Both graduates of Berea College, Alice was a teacher and Beatty was a dentist who resided in Cairo, Illinois. Despite the racial segregation of the Day Law and some American customs, the Berea Cemetery was never segregated. (Courtesy Bernice Baxter.)

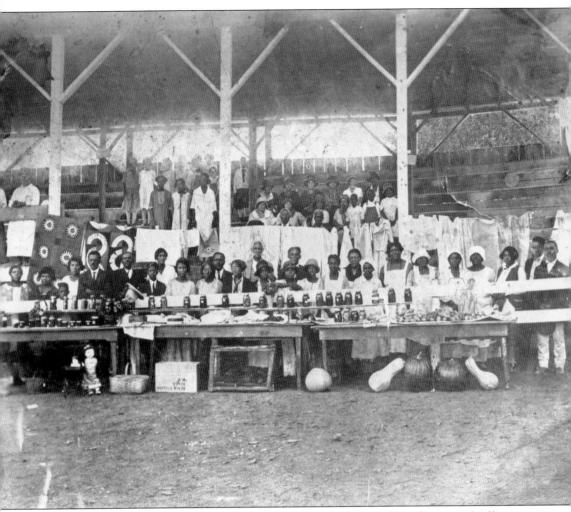

Quilts, giant pumpkins and squash, and jars of canned vegetables, fruits, and jellies were exhibited during the annual African American fairs, organized by Berea-educated Henry A. Laine, who was the extension agent for Madison County's 6,000 African American families. Men and boys formed corn, pig, and potato clubs. Women and girls formed poultry, sewing, canning, quilt making, cooking, and gardening clubs. Farm and homemaker clubs were popular. (Courtesy Elizabeth Denney.)

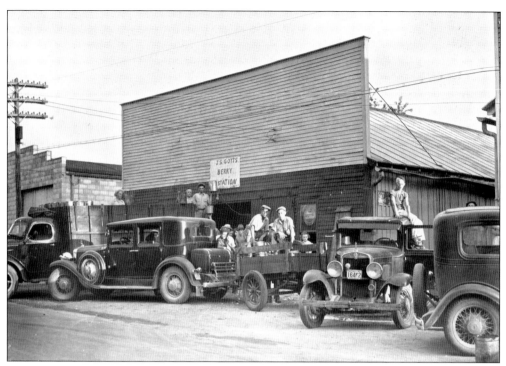

Wild blackberries were in special demand by Cincinnati (Ohio) winemakers and food companies. Each summer, the young people would pick berries and sell them to Gotts, who would ship them on the railroad to his customers. Gotts Berry Station was on Chestnut Street, up the hill from the L&N train depot. (Courtesy Berea College.)

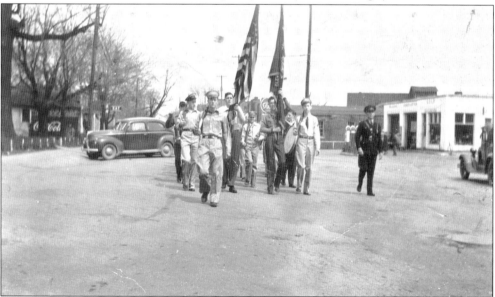

During World War II, Berea had a Defense League, pictured here in 1944 parading down Chestnut Street in Berea. Some of the members were Frances Hammond, Jimmy Bowman, Tony Scott, Ed Williams, and Duty Gabbard. A Blue Grass Army Deport guard named Collins is marching with the troops; others are unidentified. (Courtesy Melvin Higgins.)

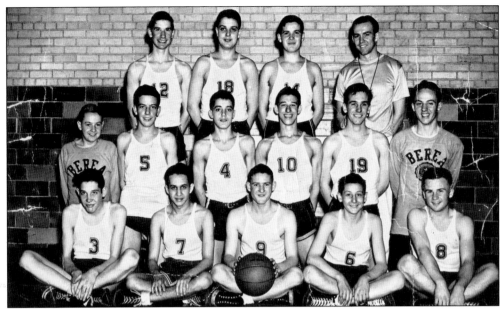

Berea College Foundation School served as a boarding high school for college-bound students from Appalachia and other countries. Members of the 1944 basketball team pictured are, from left to right, (first row) unidentified (a Cuban), Salustiano Ortiz, unidentified, Glen Stumbo, and unidentified; (second row) Melvin Higgins, Roy Holbrook, Bob Thomas, Everett Roy, Jim Beck, and ? Barnes; (third row) Tom Spillmen, Everett Back, Bill Morgan, and Coach Bob Clements (Navy V-12 unit). (Courtesy Melvin Higgins.)

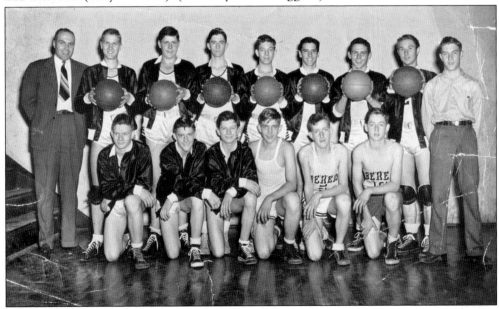

The Berea City independent school district's high school had this basketball team in 1941–1942. Pictured are, from left to right, (first row) Russell Parsons, Duty Gabbard, Harold Thomas, Jimmy Bowman, Bobby Hart, and Billy Hamilton; (second row) principal and coach C. R. Herron, Harold Brande, Tony Scott, Bobby Bottom, Earnest F. Taper, Billy Keith Williams, Bear Cornett, Harold Williams, and manager ? Williams. (Courtesy Melvin Higgins.)

Four

BOBTOWN

To raise money, the Ladies Aid Club of New Liberty Baptist Church held a baby contest in April 1950. Mothers and their babies are, from left to right, Nannie Neal with daughter Mattie Belle, Roberta Cornelison with son Lamont, Susie Gassett with son Lawrence, and Thelma Herron with son Steven Jerome. (Courtesy Roberta Cornelison.)

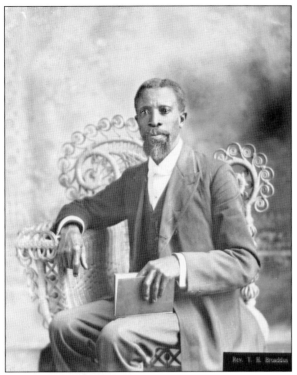

Rev. Thomas H. Broaddus, D.D., pastor of Baptist churches in Otter Creek, New Liberty in Bobtown, Paint Lick (Garrard County), Middletown, and Richmond, was a gifted speaker and great hymn singer. He was born as a slave to a white Baptist preacher, Rev. George Broaddus, *c.* 1840. During the Civil War, Thomas walked 50 miles to Camp Nelson to enlist. He married Elizabeth Ballew and had 12 children. (Courtesy First Baptist Richmond and Roberta Cornelison.)

Homecomings, or "basket rallies" as they were often called, were always the second Sunday in August for New Liberty Baptist Church. Food was brought in bushel baskets and spread out under trees by the dining room on long tables. Two women would use branches to fan the flies away from the food. This church's dining room was a separate building behind the church. (Courtesy Roberta Cornelison.)

Pictured here are three ladies of the Bobtown community, c. 1900; however, their names are lost to history. (Courtesy Roberta Cornelison.)

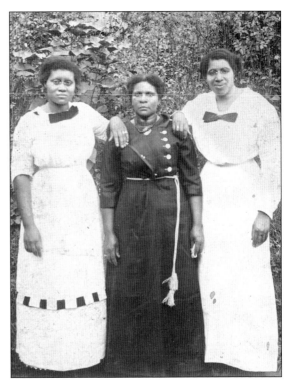

William "Hap" Baxter was revered in the Bobtown community as the only man to belong to the Ladies Aid Club; he would drive the ladies from house to house for their meetings. He was superintendent of the New Liberty Church's Sunday school and served as the church's janitor. (Courtesy Roberta Cornelison.)

After her husband, Oscar, passed away, Harriet Todd would often walk down the road to spend the day with her relatives the Walkers. One of Roberta Cornelison's favorite memories is her cousin Harriet cooking fried apples and making big, fluffy biscuits at the home of Roberta's mother, Julia Walker. (Courtesy Roberta Cornelison.)

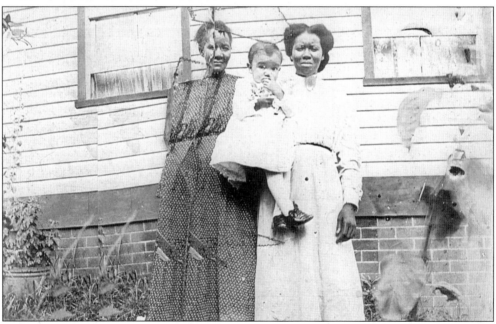

While visiting in Big Hill, Julia Neal Walker holds her son Delbert with her mother, Lizzie Neal, at her side. Information about the well-built structure is unknown. However, a free-born African American, George White, had bought 200 acres at Big Hill by 1849. Some of his descendants later married into the families of Baxter, Chenault, Ballew, Blythe, Beasely, and Walker and resided in Berea, Bobtown, Farristown, and Richmond. (Courtesy Roberta Cornelison.)

George White lived in the Berea area and for many years met the Greyhound buses in Berea. He may have attended First Baptist Church in Middletown and Union Church. He is remembered by his Bobtown friends. (Courtesy Roberta Cornelison.)

Delbert Neal and his wife, Nannie Harris Neal, share a meal with his grandmother Julia Neal Walker at her home. Nannie had three children—Sadie, Smira, and Woods Harris, a musician remembered for his guitar playing. In the corner, the wooden icebox kept foods cold before the widespread use of refrigerators. (Courtesy Roberta Cornelison.)

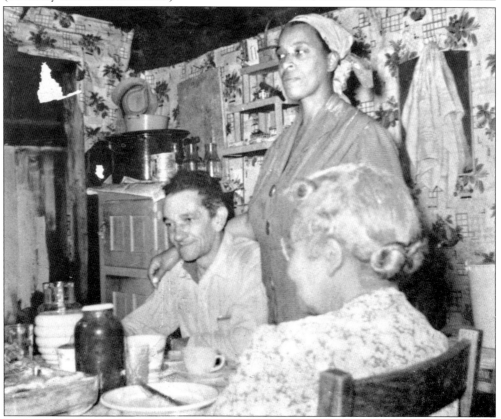

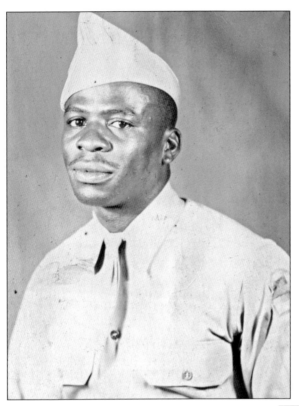

During World War II, Fount Mundy (left) served in the U.S. Army, and he and his cousin Sam Cornelison (below) served in the same unit. Both soldiers survived the war. Fount's parents were Zach and Jane Mundy of Bobtown. Sam's parents were Leonard and Birdie Cornelison. Like several other families, the Mundys and Cornelisons were active members of the New Liberty Baptist Church. (Courtesy Roberta Cornelison.)

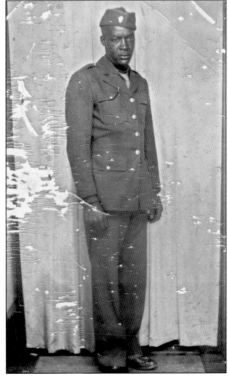

Bill Slusher lived at Red Lick, close to Pilot Knob, which is seen in the background. He may have attended the Big Hill School and later the high school in Bobtown. During World War II, Bill's army unit came under fire while they were crossing the Rhine River in Germany, and he was killed. Bill's widow, Pearl Wilson Slusher, never remarried. (Courtesy Pat Wilson.)

In World War II, civilians were required to use rations books, the federal government's way of providing a fair opportunity for people to buy scarce goods like gasoline, sugar, and other supplies needed in the war effort. Rachel Wilson saved her son's book, which still had several pages of unused stamps. (Courtesy Pat Wilson.)

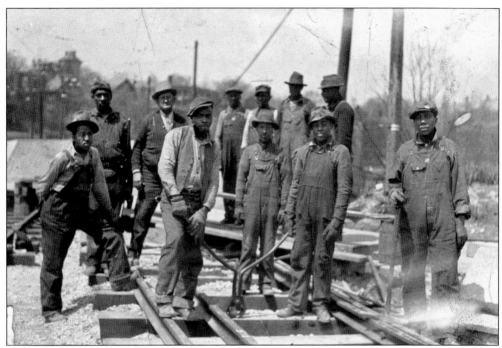

The railroad was the biggest employer of black men in Berea and other rural Madison County communities. Working as railway section hands, these men performed everything by hand. The iron rails weighed 90 pounds per foot and were handled mainly by strength and awkwardness. Other black men worked as brakemen, stoking coal into the steam engines before those jobs were unionized for white men and pay increased. (Courtesy Roberta Cornelison.)

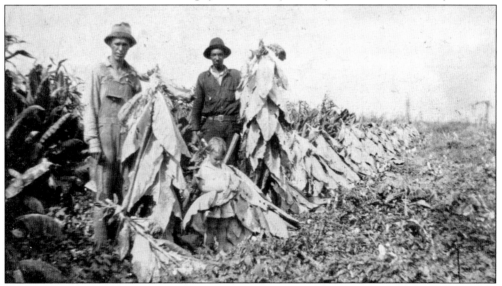

Often white and black farmers helped each other. Here farmers cutting tobacco, in August and September, watch a toddler examine leaves staked on a tobacco stick. A tobacco knife, similar to a tomahawk, was used for cutting. Cut plants were staked through a spear-tipped tobacco stick set at a diagonal so the stalks' angles kept sticks from falling while it remained in the fields a few days. (Courtesy Roberta Cornelison.)

Brothers Paul (left) and Pat, sons of Leonard and Rachel Wilson in Bobtown, are toting their full milk buckets. Their dog Chubby tags along. Farm chores for older children often included feeding the cattle every morning before school and milking the cows in the evening. In Madison County, Jersey cows were preferred for milk supply while Hereford or Angus were raised for beef cattle. (Courtesy Pat Wilson.)

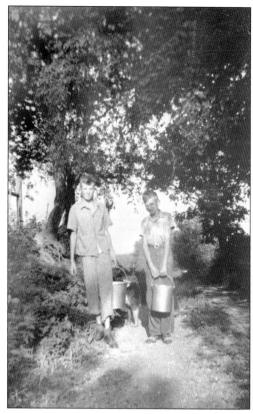

Terri Cornelison is not really feeding the piglets, but she is seeing that pigs are important to her family's farm life. The first pigs, and cattle, in Kentucky were supposedly brought by Daniel Boone. So besides being barnyard entertainment, pigs were a cash source and a food staple. Folks were said to be "eating high on the hog" when they had hams, pork roasts, and chops. (Courtesy Roberta Cornelison.)

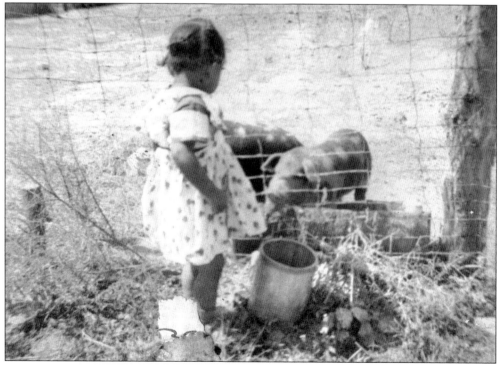

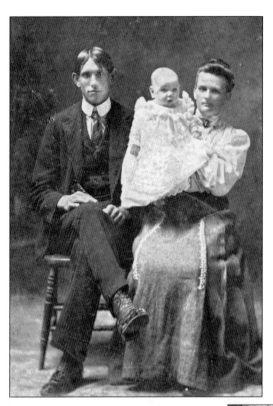

Barnett "Barney" and Belle Wilson hold their firstborn son, Alford, in this family portrait taken around 1906. Barney became known for being a hard taskmaster in working his sons on their farm. He provided them with clothes and plenty of food, but he did not pay them any money. After becoming adults, Alford and his brother Joe migrated to Ohio to work in the Champion Paper Mill. (Courtesy Pat Wilson.)

Although Barney and Belle Wilson had a nice home on their Blue Lick farm near Bobtown, their third son, Leonard, decided he was worked too hard and climbed out his second-floor bedroom window, slid down the porch post, and joined Alford and Joe at the paper mill. When his father arrived to bring him back home, Leonard said he would go when his brothers did. Years later, he returned. (Courtesy Pat Wilson.)

Rachel Wilson takes a playful turn with her children's wagon. She grew up in Clay County and attended the Oneida School, whose mission to bring education and social uplift to the mountain people was similar to Berea College's Appalachian interests. She married Leonard Wilson when she was about 18, and they reared six children in Bobtown. (Courtesy Pat Wilson.)

Three friends from Bobtown traveled to the Kentucky State Fair in Louisville. Pictured from left to right are Lena Blythe, mother of Lois Blythe Tevis; Odell Baxter, wife of William "Hap" Baxter; and Julia Walker, mother of Roberta Cornelison. (Courtesy Roberta Cornelison.)

Standing on the steps of their Bobtown Graded School are girlfriends (from left to right) Lena Benge, Mabel Smith, and Rosa Wilson. Other friends of Lena Benge included Roberta Cornelison, who attended school across the road. In Bobtown, the graded school for white children and the graded school for black children were located across the road from each other. (Courtesy Pat Wilson.)

Young girls posed in the yard of the one-room Bobtown School for African Americans are, from left to right, (first row) unidentified, Marietta Frye, and Rowena Cornelison; (second row) Elizabeth Dunson, unidentified, and Thelma Gassett. Note the crooked tree in the background on which students enjoyed playing by pretending they were riding a horse. Former teachers remembered are Prof. R. H. Royston, Frances Jackson, and Willie Campbell. In the 1930s, students were bused to the Middletown Consolidated School (grades one through eight) and to Richmond High School. (Courtesy Roberta Cornelison.)

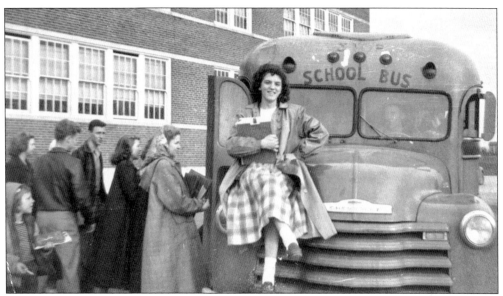

When their neighborhood school closed, Bobtown's white students were bused to the consolidated graded school (grades one through eight) and high school in Kingston. Equipped with a gymnasium, the Kingston Trojans soon became a force to be reckoned with in basketball. Pictured here sitting on the hood of the bus is Nina Faye Smith (a cheerleader). The first four people standing in line are identified as Barbara Jo Cornelison, Christine "Teenie" Maupin, Oliver Frye, and Buford Mayne, but the others are unidentified. (Courtesy Pat Wilson.)

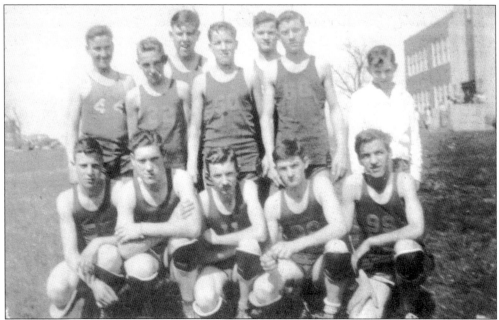

Members of the Kingston Graded School basketball team (seventh and eighth grades) were undefeated (12-0) in 1946. Posing in front of Richmond's old Central High School are, from left to right, (first row) Baxter Kelly, C. H. Brock, Pat Wilson, Curtis Lane, and Earl Bowling; (second row) John Hisle, Dickey Warford, Paul Ramsey, Ralph Mayne, Claude Smith, Charles Hubbard, and manager Jackie Robinson. (Courtesy Pat Wilson.)

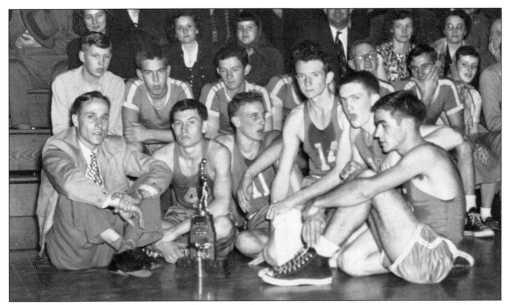

The 1949 Lions Invitational Basketball Tournament involved high school teams from Waco, Berea Foundation, Berea High, Irvine (Estill County), Kirksville, McKee (Jackson County), Kingston, and Lexington Latin (Fayette County). The Kingston Trojans defeated the Waco Cardinals 35-34. Pictured are, from left to right, (first row) Coach Shelby Winfred, Charles Hubbard, Dickie Warford, Pat Wilson, Gerald Tudor, and Earl Bowling; (second row) manager Asa Hord, George Gover, Curtis Lane, Bobby Burton, Vernon Proctor, and Wade Gay. (Courtesy Pat Wilson.)

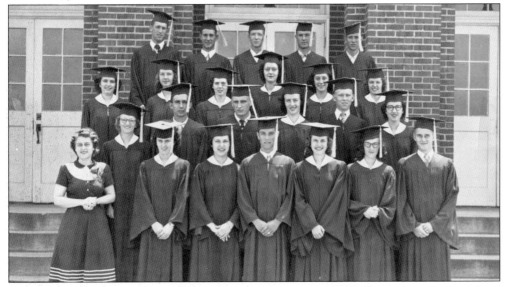

The 1951 graduates at Kingston High School are, from left to right, (first row) Lois Easterling, Wilma Gabbard, Susie Hensley, Paul Lake, Hazel Lamb, Evelyn Marcum, and John C. McWilliams; (second row) Christine Barrett, Bobby Burton, Dickie Warford, Lillie Gabbard, Asa Louis Hord, and Laura E. Todd; (third row) Dale Terrill, Margaret Rogers, Mildred McKinney, Victoria Williams, Ruth Benge, and Barbara Jo Cornelison; (fourth row) James A. Lane, Wade Gay, Pat Wilson, Charles Hubbard, and Oliver Frye. (Courtesy Pat Wilson.)

This unidentified Bobtown man sits on his horse. (Courtesy Roberta Cornelison.)

Paul Lakes, a 1951 Kingston High School graduate, sits on his Wizard motorbike, which he personalized with a foxtail on the handlebar. Unfortunately, within a few years, Paul died in a car accident less than a mile from his home. He left behind a wife and young children. (Courtesy Pat Wilson.)

Enjoying a leisurely afternoon in her front yard, Smira Harris Turner presents a special smile. Her home was located on Smith Lane, near the Bobtown one-room school. (Courtesy Roberta Cornelison.)

Here Pat and Ann Bowman Wilson visit his home place on Blue Lick Road in Bobtown. Ann's home was Farristown, where white and black children were raised together, and if there was a revival or funeral, everyone went. She enjoyed most Sunday dinners with Arthur and Spicie Farris. Under segregation, the Bowmans were bused to Kirksville (grades 1–12) while their African American playmates attended Middletown (grades 1–8) and Richmond High. (Courtesy Pat Wilson.)

Five

FARRISTOWN

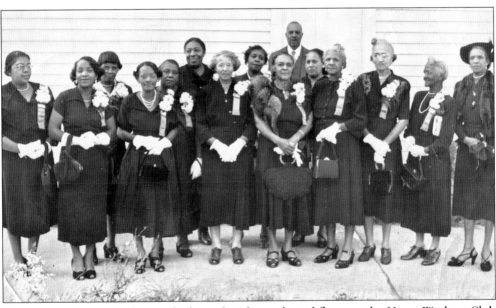

Dressed in black and white and adorned with pearls and flowers, the Merry Workers Club members celebrate their anniversary in 1953. Their service projects included upkeep of the Farristown Cemetery and assisting with church projects and neighbors' needs due to illness and other problems. The Merry Workers Club also cooperated with other groups, such as ladies clubs at the New Liberty and Peytontown churches, to help them carry out their projects. As they met monthly "from house to house," members' children gladly anticipated refreshments. Pictured are, from left to right, (first row) Emmies Bennett, Fannie Martin Ballard, Sylvania Mundy, Spicie Farris, Nancy Bennett, Lucy Martin, Mary Farris, Margaret Miller, and Kate Howard (program speaker from Lexington who was state president of the Baptist Women Education Convention); (second row) Margaret Farris, Estella Farris, Mary Proctor (the pastor's wife), Nettie Farris, Cornett Baxter Ballard, and Rev. William Proctor. (Courtesy Pat Ballard.)

Arthur "A. J." Baxter stands by his house in Farristown. A student in the Intermediate Department at Berea in 1893 who excelled in carpentry, he graduated from Wilberforce University (Ohio) after the 1904 Day Law was enacted. Baxter worked on the woodwork for Kentucky and Georgia capitol buildings. He married Joella White, the daughter of Charles and Vina White of Berea. Having attended Berea through the A Grammar, senior level, Joella White taught school at Big Hill. Later the Baxters became prosperous farm owners who also owned and operated their Farristown General Store. Baxter built their home and constructed their store with red bricks. One grandson of Baxter was Paul Dunson, who lived across the road from the old general store. Dunson helped rescue the White Family Cemetery on Glade Road from being lost when the new Berea Post Office was being constructed. (Courtesy Bernice Baxter.)

"Have You Been to the Water?" is sung often by congregations on the occasion of a baptism. Farristown Baptist Church conducts new members' baptisms in Baxter's Pond. Reverend Proctor (in black robe) and deacon Grant Walker help an elderly man, Lenoa Easley, out of the water onto the bank. (Courtesy Pat Ballard.)

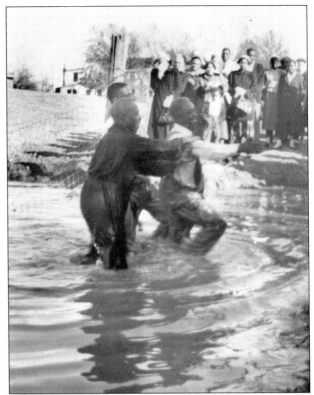

Rev. William Proctor (left) talks quietly with nine-year-old Pat Ballard, whom he is about to baptize by immersion in the water, while deacon Grant Walker stands by to assist. Farristown Baptist Church was established in 1883 with three preachers, Rev. Thomas H. Broaddus, Rev. K. C. Smothers, and Rev. Spencer Young, conducting dedication services for the new church. (Courtesy Pat Ballard.)

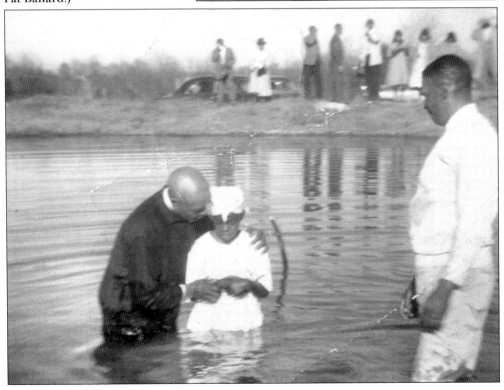

The New Liberty Sunday School Convention meets annually, and in this 1950s photograph, delegates from member churches meet at Goodloe Chapel in Brassfield, which is east of Richmond in Waco. Included in the image is Reverend Proctor of Farristown (man in dark suit kneeling left of center). Pictured are (first row) Cecil Chenault of Mount Nebo Baptist (seated 8th from left); Ruth Ann Burton (9th from left); Alonzo Ballard of Farristown (10th

from left), the convention's youth department director; Fannie Farris Ballard (13th from left); Lucille Parks (14th from left); and Ophelia Anderson Searcy of Pleasant Run Baptist (Garrard County) wearing the white hat (far right). In the fourth row fourth from left is Rev. George W. Lockhart of First Baptist Middletown. (Courtesy Pat Ballard.)

In the spring of 1957, Farristown Baptist's Sunday school poses for this photograph. Pictured from left to right are (first row) Deborah Broaddus (looking back), Marilyn Martin (leaning), unidentified, Stevie Clay, and Janice Broaddus; (second row) Darnell Martin, Carolyn Ballard (in shades), Pat Ballard, Sally Walker, and Mrs. Emmies Bennett (the Sunday school superintendent and "mother to all"); (third row) Pearl Martin (turned), associate pastor Rev. Alonzo Ballard, Minnie Clay, and Lorenzo White. (Courtesy Pat Ballard.)

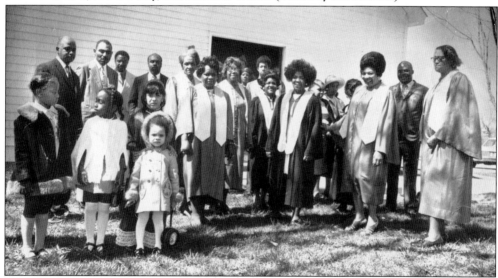

Farristown Church choir members and children are, from left to right, (first row) Pastor Beard's young niece, Felicia Ballard, Tanya Bosley, and Laura Munday (behind, in ruffled dress); (second row) Rev. Alonzo Ballard, Pastor J. C. Beard, deacon Lorenzo White, trustee Harry Broaddus, Rebecca Warford, Sally Walker, Florence White (in glasses), Fannie Ballard, Pat Ballard, Eva Mundy, and Margaret Blythe; (third row) Flossie Beard (in doorway), Michael Blythe (in doorway), Emmies Bennett, Elizabeth Hicks (in hat), and Eugene White. (Courtesy Pat Ballard.)

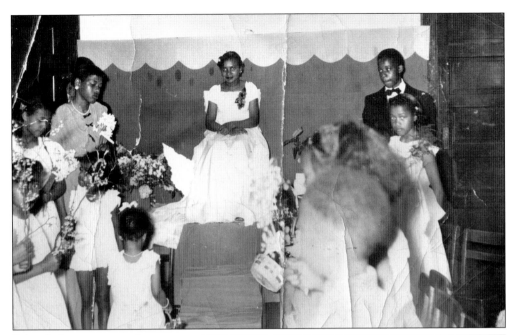

School plays were a welcome recreation for the whole family. A school bus would pick up the families to drive them to school for the evening's performance. Teacher Nancy Deatherage directed *Tom Thumb*, while Aline Bush Kennedy played the operetta score on piano. Actors included Betty Lou Raines (Queen), Patricia Farris Shearer, her brother Archie Farris, and Sandra Faye Ballard (in the short dress), who were all attendants. (Courtesy Pat Ballard.)

The Seals family moved from Rockcastle County to Farristown. Preston Seals trained his favorite horse, Ginger, to perform many tricks. One day while working for Robert Ross, an African American farmer, young Seals wanted to hurry so he could attend Berea's horse show. However, he had to slow the tractor when Ross fussed that hay could not be baled that fast. They did finish before the show. (Courtesy Preston Seals.)

Farristown Baptist Church prepared for their 115th anniversary under the guidance of longtime members Harry Broaddus and Pauline Bennett Banther. (Courtesy Pat Ballard.)

For 35 years, Alonzo and Fannie Ballard spent their summers cooking at the YMCA's Camp Ernest in Burlington, Kentucky. Their summer job turned out so well that they began taking their daughters along when each became old enough, and not only did the family work together, but they also sang as a performance group. Taken around 1957, this photograph of the close-knit family shows, from left to right Alonzo and Fannie with daughters Saundra Faye, Patricia, and Carolyn. Despite the segregation at Camp Ernest, which only admitted white groups, the Ballard daughters helped integrate the facilities because they went swimming, horseback riding, and enjoyed other activities with the 4-H, church groups, and weekend family campers. (Courtesy Pat Ballard.)

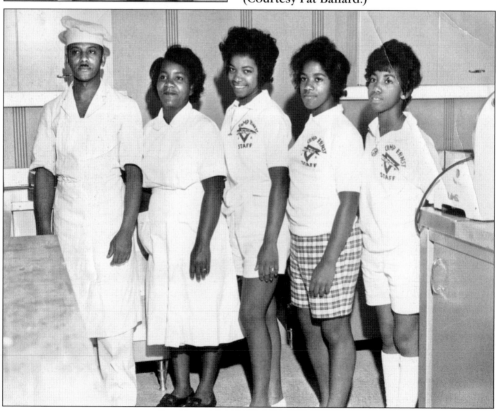

Six

MIDDLETOWN

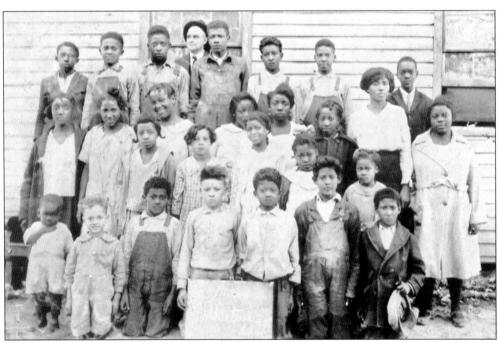

Picture day comes to old Middletown Colored School. Seen from left to right are (first row) John Lee Herd, Strother McBain, Wilbur Reed, Robert Rice, and three unidentified Pettifords; (second row) Velma McKinney, Mary Rice, Gladys "Ann" Denny, Tillie Miller, and unidentified; (third row) Olivia ?, Ernestine Bell, Dorothy Willis, Ethel Rice, unidentified, Hazel Elmore, teacher Mattie Blythe, Tom Ross, and Mary Ellen Walker; (fourth row) Stanley Ballard, Curry Ballard, Waylon Ballard, Wallace Miller, William Miller, and Frank Green ?; (fifth row) school superintendent Benjamin Edwards. (Courtesy Jesse Ward.)

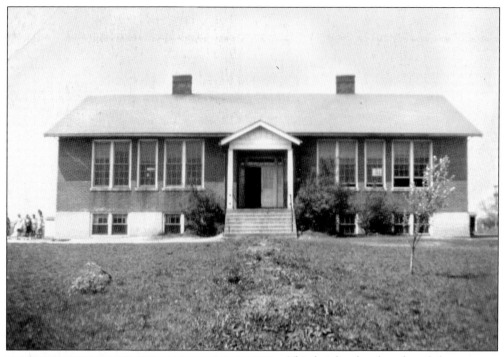

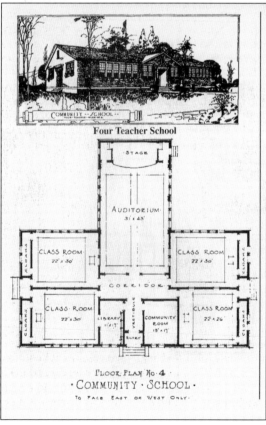

Four Teacher School

FLOOR PLAN No. 4
· COMMUNITY · SCHOOL ·
To Face East or West Only.

This brick school replaced the wooden one at Middletown and allowed for the consolidation of several one-room schools for African Americans. African American students from the southern end of Madison County, Bobtown, Farristown, Grapevine, Peytontown, and Brassfield joined those from the city of Berea to attend this school for grades one through eight. In operation from 1927 to 1963, the school had as its principal Prof. Robert Blythe, a World War I veteran who earned a B.A. from Kentucky State College in 1922 and a master's degree from the University of Cincinnati in 1938. Middletown Consolidated School was constructed based on the Rosenwald four-teacher design, and funds came from the Julius Rosenwald Fund and residents. Berea College donated land for the school and constructed electric and water lines to the building; however, the school never had indoor toilets. The outdoor privy for girls was on one side of the school yard while the boys' privy was on the opposite side. (Courtesy KAAHC.)

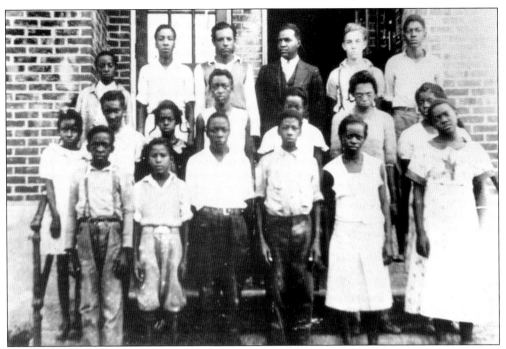

Robert Blythe, principal and teacher of Middletown Consolidated School, poses with students of 1934–1935. Pictured are, from left to right, (first row) Bill Gentry, unidentified, Laurence Farris, two unidentified, and Nannie Gentry; (second row) Ruby Turner, Hazel Rice, Mary Morton, Margaret Bigg, Curly Farris, Johnny Jenkins, and Pearlena Farris; (third row) Roosevelt Martin, Eugene Farris, George Lemons, Robert Blythe, Harold Doe, and Jesse Kennedy. (Courtesy Marcella Matthews.)

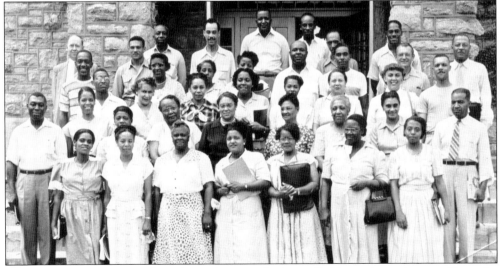

Robert Blythe (second row, far right, in the striped tie) enrolled in graduate classes at Kentucky State University (Frankfort) during the summer, as did numerous other black teachers during the era of racial segregation. Meanwhile, white teachers of Madison County could enroll in Eastern Kentucky University, located at Richmond (Madison County). (Courtesy Robert Blythe collection.)

Dorothy White Miller taught third and fourth graders in one of the four classrooms of the Rosenwald-designed Middletown Consolidated School. Growing up north of Richmond, Miller attended Calloway Creek School and later graduated from Richmond High School. Her grandfather, Mitchell White, helped organize New Providence, a Methodist Episcopal church (African American), at River Hill in 1887. Her maternal grandfather, Buell Ballew of Waco, attended Berea College from 1880 to 1882. (Courtesy Dorothy Miller.)

Teacher Laura Belle Stone is seen with her students in 1934–1935. Pictured from left to right are (first row) Elsie Porter Farris, Ethel Martin, Fannie Martin, Elizabeth Farris, Lorene Lemons, Elizabeth Ballard Denney, Mary Alice Turner, Alma Jean Jenkins, Ruth Rice Kennedy, and Mary Catherine Gentry; (second row) Beatrice Miller, Elizabeth Shearer, Ella Mae Farris, Maggie Walker, Geneva Denny, Hattie Boggs, and Dicie Miller; (third row) George Farris, Floyd Herron, Charles ?, Laura Belle Stone, Robert Jenkins, unidentified, and ? Farris; (fourth row) Clifford Ballard, Johnny Walker, William Miller, Frank Ballard, Billy King, Tom Campbell, and Clarence Herron. (Courtesy Robert Blythe collection.)

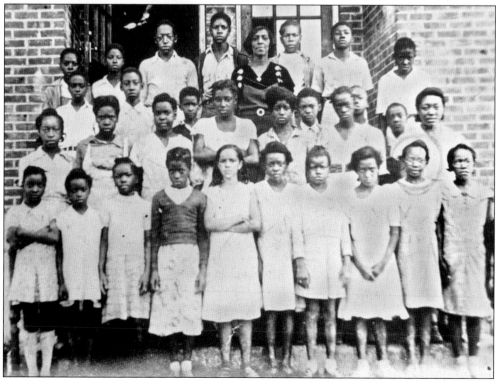

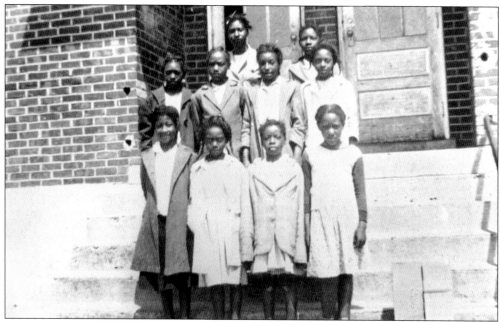

These Middletown classmates (above) are in the upper elementary grades in 1946. Pictured from left to right are (first row) Marcella Miller, Ann Peyton, Delphine Martin, and unidentified; (second row) Irma Kennedy, Bobbie Boggs, Frances Moran, and Shirley Peyton; (third row) Iva Jean Farris and Katherine Martin. Below is the 1934–1935 class of first and second graders. From left to right are (first row) "Curley" Farris, unidentified, Stella Lemons, Henrietta Clark, Gonzella Blythe, Elizabeth Rhodes, Dorothy Farris, Stella Herd, two unidentified, Laura King, and Elizabeth King; (second row) Elizabeth Kennedy, unidentified, Josh Gentry, Charles Bronaugh, Delphine Scudder, Eugene Scudder, Doug Moran, Louis Shearer, Alfred Rice, Albert Moran, John Rice (overalls), and George Shearer; (third row) Burt Herd, Elnora Walker (under the teacher's hand), teacher Willette Embry, ? Farris, "Fat" Shearer, George Clark, Mac Herron Jr., and Mary Elizabeth Morton; (fourth row) unidentified, ? Farris (overalls), Virgil Clark, Wayman Miller, unidentified, and Roy B. King. (Both courtesy Robert Blythe collection.)

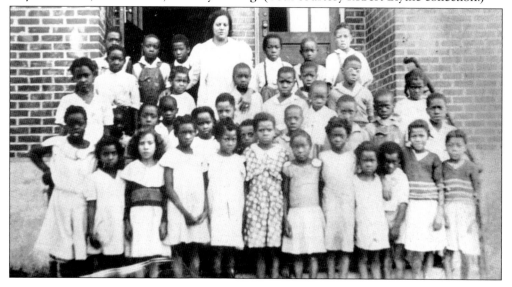

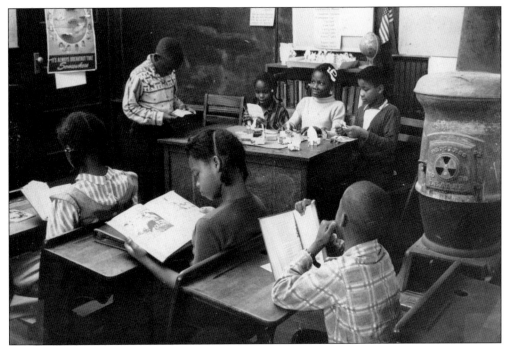

Fourth graders seated at teacher Dorothy Miller's desk are, from left to right, Helen Herron, Alice Crutcher, and Breen Miller. Third graders seated at student desks are unidentified except for Michael White (plaid shirt), and the student standing is unidentified also. Each of the four classrooms had a potbellied stove, and teachers came early to make a fire before the children arrived. Larger schools had a janitor, but Middletown did not so the teachers and students kept the floors swept and everything clean. During the latter years of the school, the county superintendent did hire a janitor for Middletown. (Courtesy Dorothy Miller.)

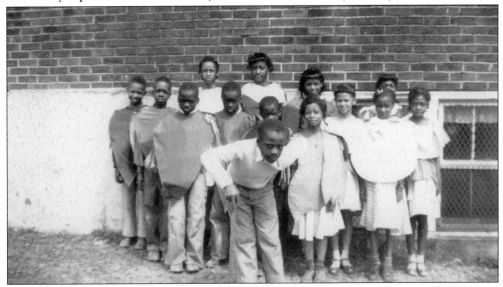

In the second act of *Peter Rabbit*, the vegetable chorus sang and danced to several songs, including "Basking in the Sunlight." The chorus then joins Peter on the song "I Thank you for your Hospitality" to close out Act 2. (Courtesy Dorothy Miller.)

Teacher Charles M. Irvine was a 1913 graduate of Richmond High School. She completed the two-year Normal School program at Knoxville College (Tennessee) and more advanced courses at Kentucky State College in Frankfort (Franklin County). She had taught for a number of years at rural Madison County schools, like Four Mile School near Richmond, before being assigned to the Middletown Consolidated School. (Courtesy Dorothy Miller.)

At Middletown during recess—15 minutes in the morning and 30 minutes after lunch—students enjoyed a variety of playground equipment such as this slide. The Middletown school yard extended to the railroad tracks, and between the playground and railroad tracks was a pond that teachers could take students to in order to observe pond life. Once students found an albino frog and brought it back to their classroom. (Courtesy Dorothy Miller.)

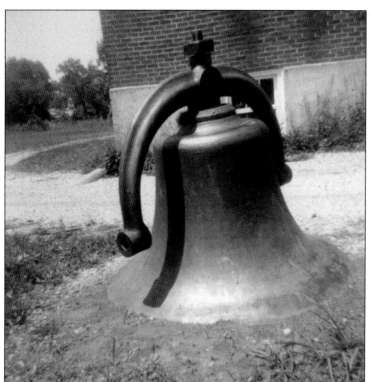

Donated to the school, this bell remained on the ground due to lack of funds to have it appropriately mounted. Schoolchildren, however, never tired of playing with it during recess. Cast by the McNeeley Bell Company (of Troy, New York), this bell had been used by Reverend Fee at Camp Nelson. Afterwards, he brought it to Berea to use at the college. (Courtesy Robert Blythe collection.)

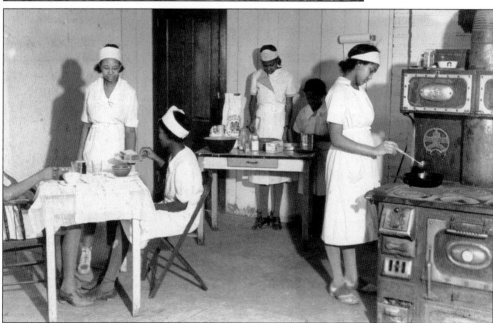

Here Middletown 4-H Club students learn to cook and serve. Ruth Rice (left) serves bread to an unidentified student while Alma Jenkins (right) and Mary Elizabeth Kennedy (rear table) are aided by an unidentified student. The school was built without a cafeteria so students would bring their lunch of biscuit and sausage or biscuit and jam. Excavating the basement allowed construction of a kitchen. (Courtesy Robert Blythe collection.)

Henrietta Child, Berea's storyteller, visited elementary classes in all the local schools, including the Middletown Consolidated School. With her doll characters, she told classic stories with such skill that former students, black and white, still have fond memories about the way she brought story characters to life. (Courtesy Berea College.)

Born in 1910, Myrtle Ballard attended Berea's one-room graded school for African American children on Fee Street, with classes taught by Robert H. Royston, a Berea College–educated black man from Kirksville. To attend Lexington's Dunbar High School, Ballard boarded with relatives. After graduation, she completed three years of nurses' training at the Freedmen's Hospital in Washington, D.C. After returning home, Ballard was the school nurse for Middletown School and Richmond High School. (Courtesy Linda Ballard.)

Aline Bush Kennedy, pictured here in 1940, was an accomplished pianist who played for the Middletown Consolidated School operettas and for various churches in the area. She married Willard Kennedy, and they reared six children. Her father was Frank Bush. (Courtesy Gail Kennedy.)

This portrait of the adult children of Ashford and Fannie Route Kennedy was taken around 1940. Pictured from left to right are (first row) Julius, Herman, and Willard; (second row) Clifton, Alma, and Jesse. Born in 1892, Alma was oldest, followed by Herman (b. 1893), Julius (b. 1895), Willard (b. 1905), Jesse (b. 1912), and Clifton (b. 1919). Herman was almost seven feet tall. (Courtesy Gail Kennedy.)

Fannie F. Route Kennedy stands among chickens at her Glades Road farm. In the background is a well covered with a water pump. Born in Lancaster (Garrard County), she married Ashford Kennedy, who was a farmer and Union Church's janitor until 1925. His faithful service, optimistic outlook, and bits of wisdom were appreciated by church members. Kennedy's youngest son, Clifton, replaced him as janitor before migrating to Ohio. (Courtesy Gail Kennedy.)

The older Middletown wooden school closed when the new brick Rosenwald building opened. Anne Marie Herd converted the old school building into a house and lived there for many years. (Courtesy Bobbie Boggs.)

Several Middletown residents joined their neighbors at the Farristown Church, which was decorated for a banquet, to celebrate a special occasion. Some folks present were Lucy Martin, Emmies Bennett, Margaret Miller, Gladys Walkers, and Tom Mason. Those seated on the pulpit included Gray Walker and pastor Reverend Proctor and his wife. Some of the families that the children represent are Farris, Jenkins, and Mundy. (Courtesy Pat Ballard.)

Another resident of Middletown was "Fiddling Cal" Miller, a local fiddle player who traveled and was often sought out to play for parties. (Courtesy Marcella Matthews.)

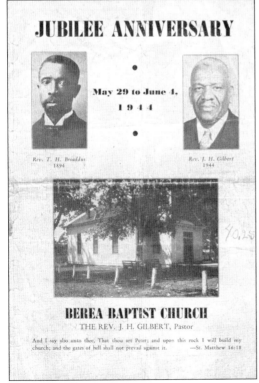

In June 1944, activities to celebrate First Baptist Church's 50th anniversary included a banquet on Saturday and church services on Sunday. Participants from the neighboring towns of Farristown and Bobtown attended, as well as long-distance guests from Louisville (Jefferson County). (Courtesy Pat Ballard.)

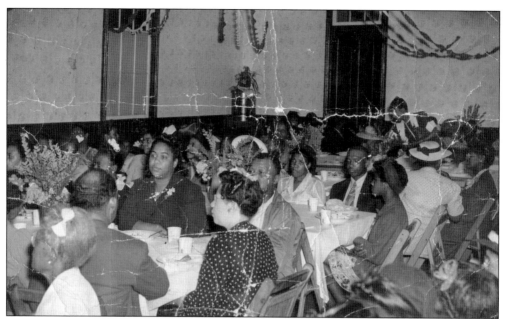

This 1944 photograph provides a view of some of the attendees at First Baptist Church's 50th anniversary celebration. The elderly lady with the bow in the back of her hair is Lucy Martin; others are not identified. (Courtesy Berea College.)

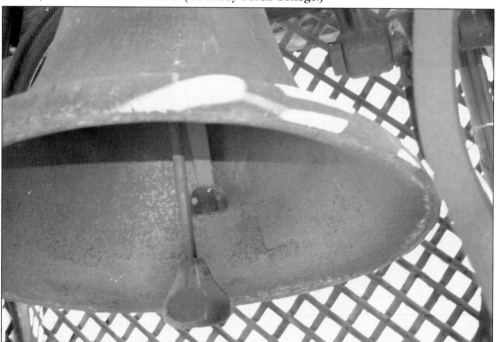

First Baptist Church in Middletown has had a bell since 1894 when the church was built. It was placed in the church's steeple and rung every Sunday morning to summon the community to services. When the current brick church was constructed in 1971, the bell was mounted in a separate little structure beside the church where it is still used. (Courtesy Historic Black Berea Project.)

Seven

PEYTONTOWN

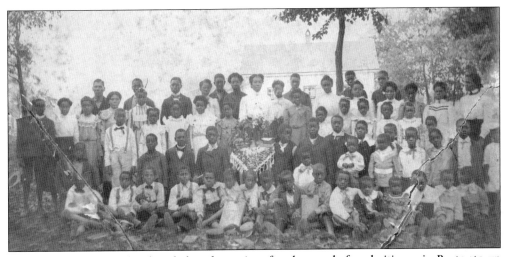

After the Civil War, school and church services for the newly freed citizens in Peytontown were conducted in the same building, which appears in the background of this photograph. A wide range of ages, from the very young to young adults, were eager to learn because under slavery, slave owners rarely permitted their slaves to learn to read and write. Madison County historians usually mention only two slave owners who actually educated their slaves. Peytontown took its name from the former slave owner Guffrey (or Guffey) Peyton, and land for the school was given by Craven Peyton. Some 40 to 60 black families once lived in Peytontown, which had two general stores. Black Diamond was the name of the store operated by Charlie Embry, Ed Mason, Henry Tevis, and Mac Miller. They sold groceries and items like coal-oil lamps. A second store operated by white owners was situated across the street. (Courtesy David Miller.)

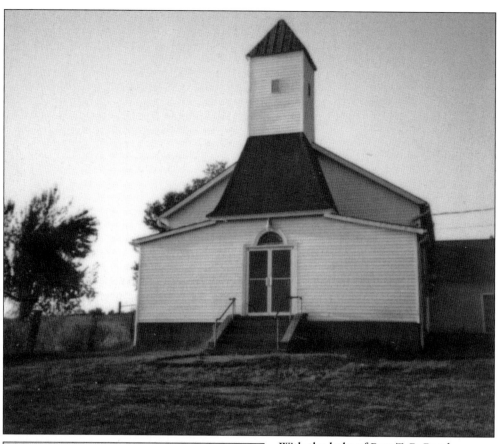

With the help of Rev. T. R. Reed
of Berea, residents organized the
Peytontown Baptist Church some 120
years ago. Twelve acres of land for
a church building were purchased
from Guffey Peyton by an African
American, Cora Campbell. She gave it
to the church under the condition that
ownership belonged to David Miller
if it was no longer used. (Courtesy
David Miller.)

Baby Martha Ann Rowlette toddles
around the yard during her visit to a
Peytontown resident. The school and
church building can be seen in the
background. (Courtesy David Miller.)

This postcard photograph of Rev. J. W. Jackson, who lived at 709 North Mill Street in Lexington (Fayette County), was mailed to Peytontown relatives. Written on the back was an announcement that Robert Burt Warner made confession of his sins, a religious conversion, on Monday night, October 22, 1923, under Rev. J. W. Jackson. Warner grew up in Peytontown, and his mother was Betty Warner. He eventually migrated and resettled in Ohio. (Courtesy David Miller.)

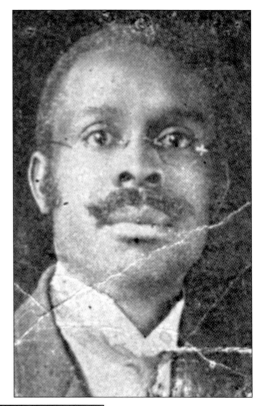

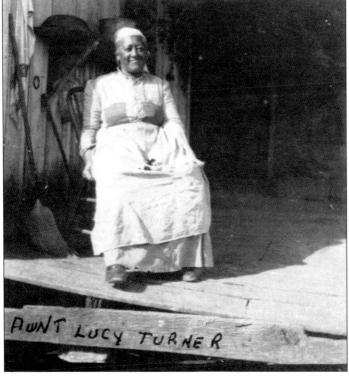

Aunt Lucy Turner is fondly recalled for her many kindnesses to residents and was known to sing the old hymns during the baptizing of new church converts. Aunt Lucy would sing a verse, then aunt Sophia Miller would sing the next verse. They were respected for being old-timers. Aunt Lucy's husband was Harry Turner, and though they had no children, they reared Lawson Shearer. (Courtesy David Miller.)

Hattie Harris of Richmond attended Berea College, studying in the Academy II from 1892 to 1896. She later became a teacher. This photograph was taken by Schlegel in Richmond. African Americans were always pleased with his quality of service. (Courtesy David Miller.)

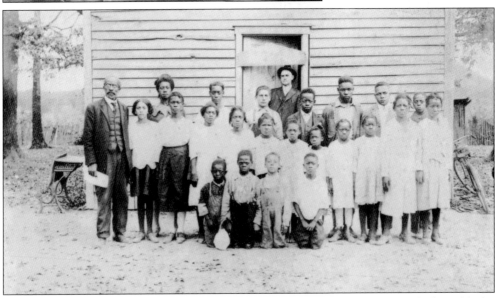

Madison County school superintendent Ben Edwards poses with this group, believed to be Peytontown students, around 1922. No others are identified though a list of former teachers include Warfield Campbell, Joe Moberly, Francis Jackson, Nancy Deatherage, H. J. Haynes, Bertha Coleman, Stella Yates, and Sarah Belle Watts. (Courtesy Jesse Ward.)

In June 1937, Annie Louise White graduated from eighth grade. While dressed for the special occasion, she posed for this portrait holding her graduation certificate. Annie, who was living in Cincinnati, Ohio, sent this photograph to her Aunt Bettie in Peytontown. (Courtesy David Miller.)

Here a young girl sits at her school desk. This photograph was in the Peytontown collection though it does not appear to be at the one-room Peytontown school. (Courtesy David Miller.)

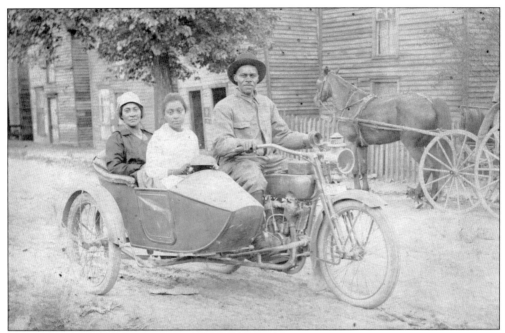

Charlie Burnam with his wife, Nannie Simpson, and daughter Helen rode around Richmond in the 1890s. Known as "Bicycle Charlie," he owned and operated a bicycle and motorcycle shop in Richmond for years. A mechanical genius, he constructed two small-scale steam engines. His smallest train engine ran on a six-inch gauge track and carried five to six adults or seven to eight children. (Courtesy David Miller.)

Here Bicycle Charlie Burnam rides his larger steam engine train, whose passenger cars carried 25 people. By 1913, Burnam was operating his trains at Fort Boonesborough and Joyland Park in Lexington (Fayette County). Passengers paid 5¢ to ride. Around 1923, Burnam moved to Covington (Kenton County) and operated his trains at Daytona Park. Later, when he suffered bad health, two white men stole his trains. (Courtesy David Miller.)

Bicycle Charlie persuaded his 16-year-old cousin, Gilbert Burnam (pictured), to learn bicycle repair and help work in his bicycle shop in Richmond. After his retirement from other work, Gilbert Burnam started his own bike repair shop in Richmond as a hobby. He enjoyed bike work to keep his mind active and was not dependent upon the business to make money. (Courtesy David Miller.)

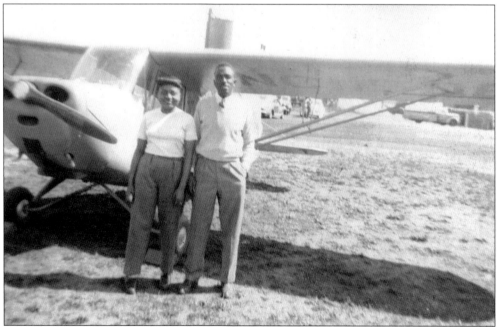

Cousins Pauline Fife and Charles Jenkins stand next to the Piper Clipper airplane that he owned and flew. Jenkins moved from Peytontown to Detroit, Michigan. After World War II, he worked as an auto mechanic and learned to fly airplanes. Fife married Ray Smith and lived in Louisville. (Courtesy David Miller.)

Adella Miller, one of Arthur Miller's sisters, grew up in the Peytontown community and later migrated north to Chicago to live. (Courtesy David Miller.)

Robert Miller, dressed in a pin-striped suit with a bow tie tucked under his clean-shaven face, wears a neatly brushed bowler-style hat and wristwatch. Working on a farm and later for the railroad, Miller has done well. (Courtesy David Miller.)

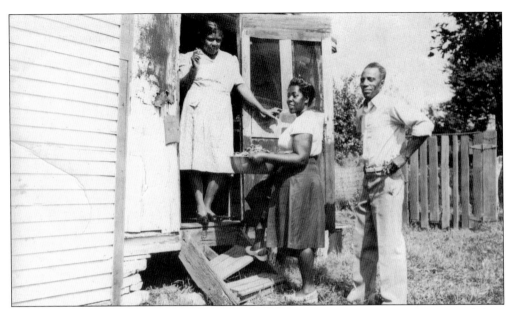

Standing in the doorway of their Peytontown house, Mary Randy holds the screened door wide open for her husband, Sam Chambers, and a friend. They have returned from the garden with a dishpan full of summer vegetables. Sam, the son of Ben and Liz Chambers, moved to Paris, in Bourbon County, to work. After retiring, Sam and Mary Randy moved back to Peytontown. (Courtesy David Miller.)

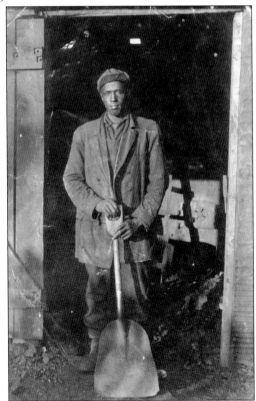

Robert Peyton pauses from his shoveling work on the farm. Many residents of Peytontown farmed their own lands as well as worked for larger farm owners. Before the 1930s Prohibition, which stopped the sale of alcoholic spirits, the Old Teller Distillery, located on a branch of the Silver Creek, employed local residents and bought grains from the farmers. (Courtesy David Miller.)

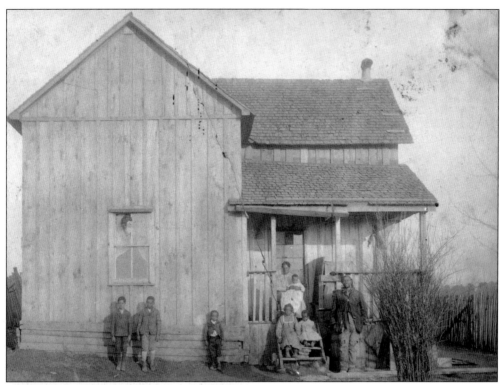

Located on Mason Lane, this Peytontown home belonged to Humphrey and Mary Brooks. Seated on the porch is Mary holding her daughter Vielena. On the steps are Bettie (left) and Can, the youngest of Brooks's three sons. Humphrey Brooks stands to the right of the steps. From left to right, the three boys are Phelbert, William, and a neighbor, George Fife. Phelbert became the father of Eva Brooks Duerson. (Courtesy Eva Duerson)

Dressed in her Sunday best, Grandma Mary Brooks sits for a photograph. She was a member of the Peytontown Baptist Church. (Courtesy Eva Duerson.)

Arthur Miller (left) sits with his friend Major Blythe. During World War I, Arthur was stationed at Camp Zachary Taylor in Louisville before being sent to France. Miller survived the war. He and his wife, Katie, reared eight children, one of whom was David. (Courtesy David Miller.)

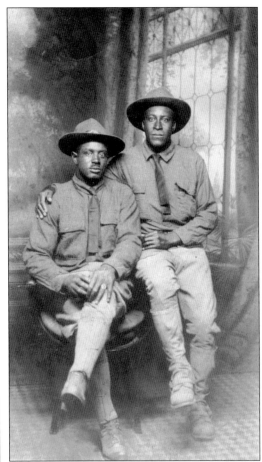

Curtis Harris, brother to John D. Harris, grew up in Peytontown. For this photograph, taken around 1920 in Cincinnati, Ohio, he wore a tie with his shirtsleeves rolled up, giving the impression from his relaxed posture that he wanted to avoid looking too formal. (Courtesy David Miller.)

Here Lizzie Blythe stands in the doorway of a house. As a young girl of 12 or 14, she attended the primary grades at Berea College in 1872. (Courtesy David Miller.)

Ann Peyton, according to the 1870 Census in the Silver Creek Post Office section, was 35 years old and keeping house. Jacob Peyton is listed first, then Ann, and seven children—Lewis (age 17), Jacob (14), Easter (12), Mattie (7), Howard (4), and Sallie (1). Sallie grew up and married Charlie Blythe. (Courtesy David Miller.)

Charlie Blythe, pictured here, and Sallie Ann Peyton Blythe were the parents of Jennie Blythe. Charlie farmed and worked on the railroad. After slavery ended, some of extended Blythe family remained in Peytontown, while others moved to Berea or Richmond. In Berea during the 1890s, Charles H. Blythe and his brothers became prosperous business owners, which lasted well into the 20th century. (Courtesy David Miller.)

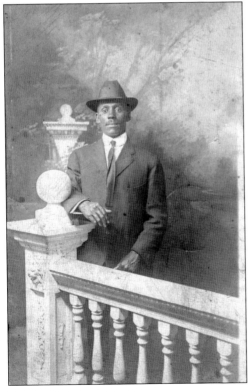

Robert Bennett lived in Peytontown but worked in Richmond as a tailor at a clothing store. Until the 1930s, the Louisville and Nashville (L&N) Railroad ran a spur track through Peytontown, and residents caught "Ole Henry," a northbound train that stopped in town at 6:00 a.m., if they needed to get to Richmond and beyond. They then caught "Ole Henry" at 6:00 p.m. to return home. (Courtesy David Miller.)

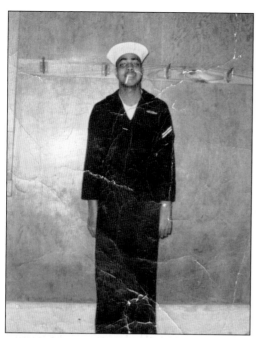

Sailor Maurice Campbell wrote back to Peytontown to keep in touch with his sweetheart, Nelva Herd. (Courtesy David Miller.)

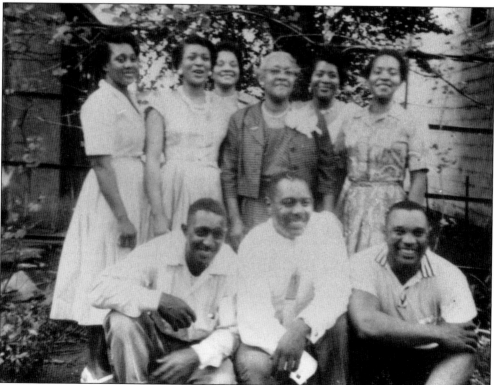

In Cincinnati, Ohio, these Peytontown relatives are visiting family members who had migrated north. Pictured are, from left to right, (first row) David, Herbert, and Chester; (second row) Eva, Olivia, Bervella, mother Katie Burnam Miller, Katherine, and Jeannie. It was Memorial Day weekend in 1953. (Courtesy David Miller.)

Eight

RICHMOND

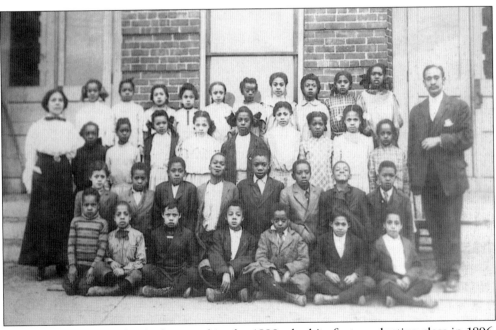

Richmond City School, which started in the 1890s, had its first graduating class in 1896. Guided by Prof. James White, as well as teachers Josie Foeman and Bell Jackson and principal Prof. C. W. Reynolds, the school's enrollment reached 200 students. By 1900, the Richmond City School was recognized as Richmond High School, and student enrollments increased to 300, with 11 teachers and principal Prof. J. D. M. Russell. Several of the teachers for the Richmond High School had been educated at Berea College before the 1904 Day Law—J. D. M. (Joe Dell Morton) Russell, who was from Russellville (Logan County) and attended Berea College from 1889 to 1898; Prof. James S. Hathaway, who was principal at the high school from 1918 to 1930, when he died; Prof. Henry A. Laine, poet laureate of Kentucky; and Prof. James A. White. (Courtesy Richmond High School Alumni Association [RHS Alumni].)

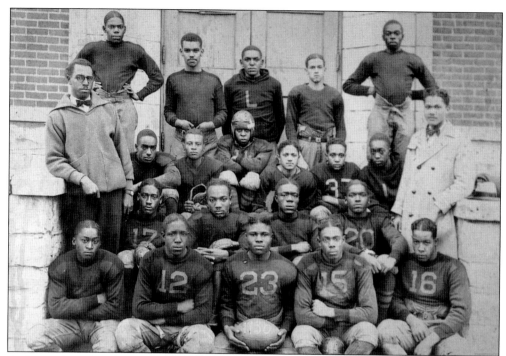

Richmond High School's 1930 football team is pictured here. Although not identified, players represent the families of Ballew, Boggs, Cobb, Stone, Walker, Miller, White, Black, and Strong. During the Depression years, some graduates migrated north to Cincinnati and Chicago, hoping to live up to their 1930 class motto of "Rowing, Not Drifting." (Courtesy Ferrell and RHS Alumni.)

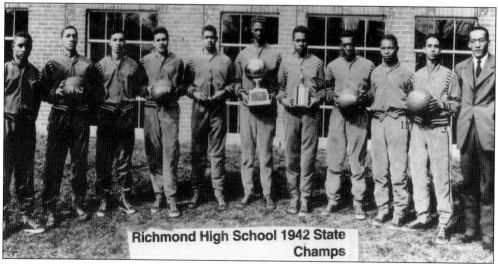

The Richmond High Ramblers won the Kentucky State High School Basketball Tournament in 1942 in Frankfort (Franklin County). They defeated Ashland 28-22 in the gymnasium on the Kentucky State University campus. Pictured from left to right are Harry Moran, Stanley Williams, Herman Dudley, Reginald Mackey, Walter Perry Black, Leroy Arthur Smith, William Leace, Allen Huguely, Tomas Allen Kennedy, William David Turner, and J. G. Fletcher, principal. (Courtesy Ferrell and RHS Alumni.)

110

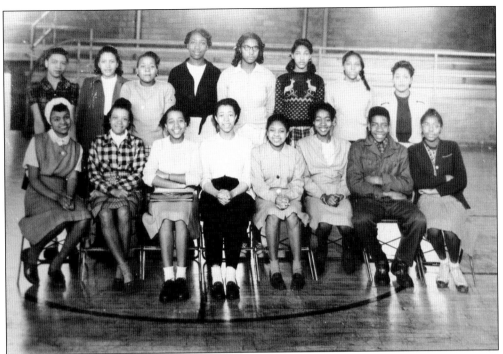

Pictured here is the 1948–1952 girls' basketball team at Richmond High School. Unfortunately, this sport was not made available to later classes in the 1950s, and the school was closed in 1956 as part of Richmond's desegregation. (Courtesy Ferrell and RHS Alumni.)

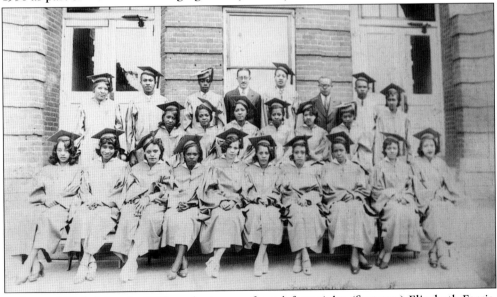

Richmond High School's 1932 graduates are, from left to right, (first row) Elizabeth Farris, Lois Duncan, Margaret Estill, Sadie Strong, Zelenia Savage, Beulah Miller, Dorothy White, Creagan Greene, Beatrice Reed, and Mary Lee Yates; (second row) Hazel Wilson, Anna K. Miller, Odell Broaddus, Lee Venia Willis, Sedalia White, and Argertha Pinkston; (third row) Geneva Broaddus, Daniel Miller, Thomas Chenault, Prof. P. L. Guthrie, Robert White, Prof. C. C. Handy, Cyrus Reed, and Elise Taylor. (Courtesy Ferrell and RHS Alumni.)

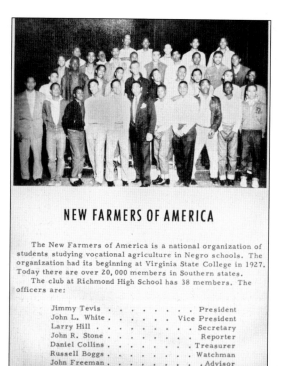

The New Farmers of America Club, pictured here around 1954, was part of a national organization that started in 1927 at Southern schools where vocational agriculture was taught. The NFA provided vocational, social, and recreational opportunities for its members as well as chapter contests and public speaking activities, all supervised by their faculty advisor. (Courtesy Ferrell and RHS Alumni.)

NEW FARMERS OF AMERICA

The New Farmers of America is a national organization of students studying vocational agriculture in Negro schools. The organization had its beginning at Virginia State College in 1927. Today there are over 20,000 members in Southern states.

The club at Richmond High School has 38 members. The officers are:

Jimmy Tevis	President
John L. White	Vice President
Larry Hill	Secretary
John R. Stone	Reporter
Daniel Collins	Treasurer
Russell Boggs	Watchman
John Freeman	Advisor

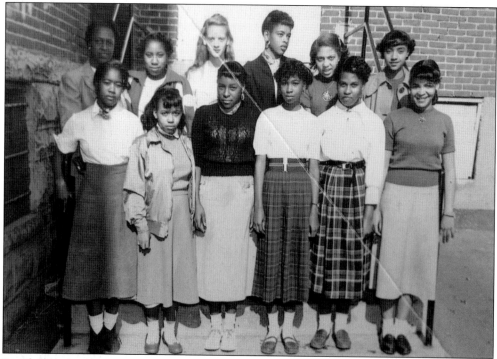

Book club members are pictured here in 1952. Students interested in library work were likely to join this club. Based on some of the RHS class reports appearing in alumni publications, several young men joined for a year or two, especially during their freshmen and sophomore years. (Courtesy Ferrell and RHS Alumni.)

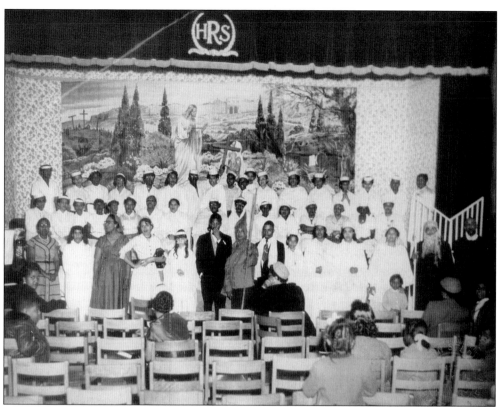

Sometimes community organizations held special events at the Richmond High School Auditorium, although no information about this particular play was available. Before the auditorium was added to the school in 1911, commencement programs were held in the Madison Theater building. A gymnasium was built in 1926, and the Rosenwald Foundation financed construction of the Richmond Shop, a manual training facility, in 1929. (Courtesy Ferrell and RHS Alumni.)

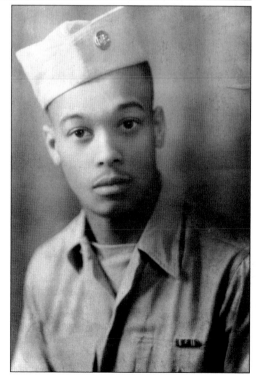

Hayden Dudley, son of Edward and Emma Collins Dudley, was attending Richmond High School when he was drafted for World War II. He served in the U.S. Air Corps (Air Force) with the 1935th Ordinance Ammunition Company. Stationed in southern Italy, Dudley worked as a telephone switchboard operator. After the war, he used the GI Bill to complete his education. Dudley became a renowned singer and performer. (Courtesy Hayden Dudley.)

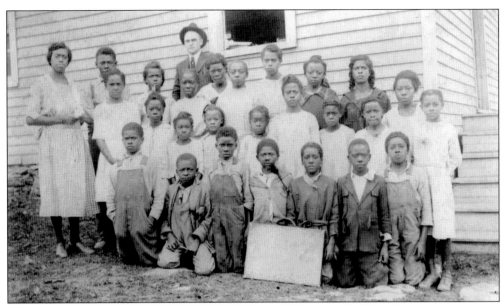

Pictured are, from left to right, Calloway Creek students (first row) Louis Twyne, Frank Turner, unidentified, Warfield Chenault, Allen Toomy, Raymond Pinkston, and unidentified; (second row) teacher Maggie Hughes, Beulah White, Argertha Pinkston, Bessie Lisle, Allene Jones, Julia Lisle, Eliza Jones (the taller girl), Gladys Lisle, Dorothy D. White, and Laura Tribble; (third row) Fielding Jones, Anna Bell Twyne, Louvenia Bentley, two unidentified, Lillian Twyne (taller), Mary Catherine Smith, and Gladys Twyne; (far rear) superintendent Ben Edwards. (Courtesy Jesse Ward.)

James Andrew White of Calloway Creek was from a family of 10. He attended Berea for a few years before the Day Law and later became a farmer and the father of Dorothy White Miller, who became a teacher at Middletown Consolidated School until it closed in 1963. Dorothy then taught at White Hall Elementary until her retirement. (Courtesy Dorothy Miller.)

Henry Allen Laine, Kentucky's poet laureate, first attended public school in an old slave cabin with split-log benches for seats. He was 18 before he completed the eighth grade. Eager to keep learning, he worked in a Clay City sawmill to earn money for his first year at Berea College and completed the Academy I in 1896. Laine married Florence Benton in 1897. (Courtesy Eastern Kentucky University.)

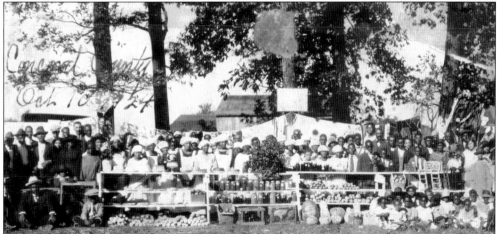

Annual county fairs like this one at Concord showed the improvements in farming, gardening, and domestic science skills learned by black residents who enrolled in county extension clubs. In 1917, Henry Allen Laine was appointed the first county agent for blacks in Kentucky. He had organized African American farmers into 20 clubs, and the members studied soil protection and improvement, farm erosion, the value of barn manure, commercial fertilizers, legumes, and winter cover crops. (Courtesy Eastern Kentucky University.)

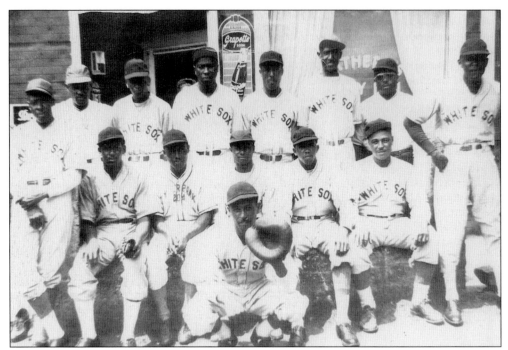

Richmond's White Sox baseball team played games in nearby cities during the 1940s. Pictured are, from left to right, (first row) William "Utsie" Martin (catcher); (second row) Allen Huguely, George Tevis, ? Martin, Ambrose Irvine, and Wallace "Possum" White; (third row) Gene Gentry, unidentified, Pugh Bosley, T. K. Covington, unidentified, Clarence Stone, Sonny Ransom, and Bobby Grubbs. Team members are outside Blythe's Restaurant, a black-owned business. (Courtesy Paul and Ruth Ferrell.)

One of several black-owned restaurants in Richmond was the H-K-H Shoppe, which was operated by Richard Holland, Bert Kavanaugh, and Johnny Huguely. In the 1950s, the employees were, from left to right, short-order cook Erskine Moore, pie cook Frances Covington, and Paul Ferrell. Covington was known for cooking the best apple pies in town. (Courtesy Paul and Ruth Ferrell.)

Two ladies of Richmond attended Berea College before the 1904 Day Law. Maud S. Mackey (left) was the daughter of Joe and Margaret Mackey. A student at Berea from 1887 to 1892 in the Academy I, she later married John Morgan Walker. Irene Pettiford (right) lived in the Glades section of Berea, and several of her brothers and sisters also attended Berea. (Courtesy Bernice Baxter.)

Mary E. Parrish was born in 1868, and her husband, Thomas S. Jones, was born in 1859. Married in May 1895 at United Baptist Church by Rev. Madison Campbell, they later became the grandparents of Paul Ferrell of Richmond. (Courtesy Paul and Ruth Ferrell.)

Brothers Paul "Dude" (left) and Charles "Jeff" Ferrell are playing around 1930. Both attended and graduated from Richmond High School. (Courtesy Paul and Ruth Ferrell.)

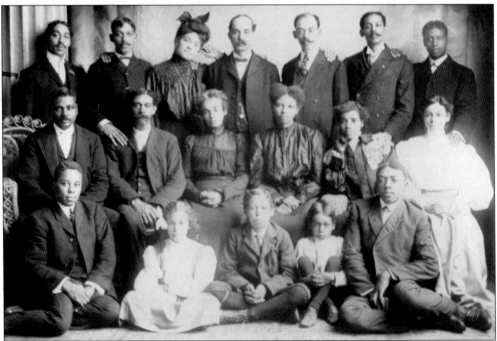

Pictured are Bernice Doe Baxter's maternal relatives from Richmond. From left to right are (first row) uncle Wallace Estill, aunt Wrighty, unidentified, uncle Gene Estill, and unidentified; (second row) unidentified, grandfather, grandmother Mary Estill, aunt Rebecca Hocker of Brassfield, unidentified, and aunt Annie Mae Estill Collins; (third row) uncle Will Estill, uncle Hayden Estill, Ella Estill Doe (Bernice's mother), uncles Bob, Webster, and Henry Estill, and unidentified. (Courtesy Bernice Doe Baxter.)

In 1937, Zeakie Jett wrote friends about his work with the Works Progress Administration (WPA) in Booneville (Owsley County). His father, Anthony Jett, operated a barbershop on the banks of the Paint Lick Creek (Garrard County). During the 1913 Paint Lick flood, Jett's shop was one of the few businesses spared massive damage due to his higher-ground location. The Jetts later moved to Richmond. (Courtesy Bernice Baxter.)

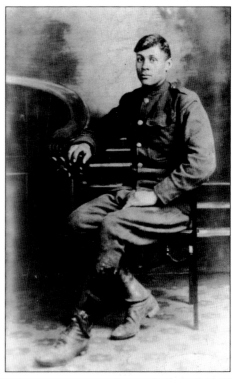

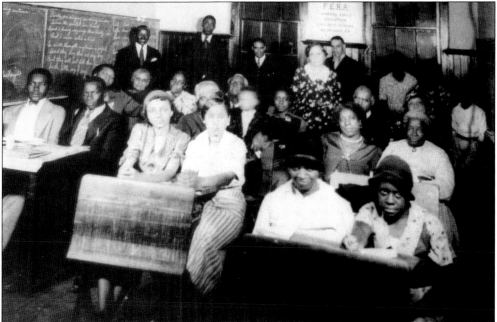

Here Federal Emergency Relief Agency workers meet in Richmond. During Pres. Franklin D. Roosevelt's administration, FERA helped the country recover from the Depression by providing state assistance for the unemployed and creating work projects that ranged from flood control, school and public building construction and repair, recreation projects for children, clothing distribution, and even toy-making shops. (Courtesy Ferrell and RHS Alumni.)

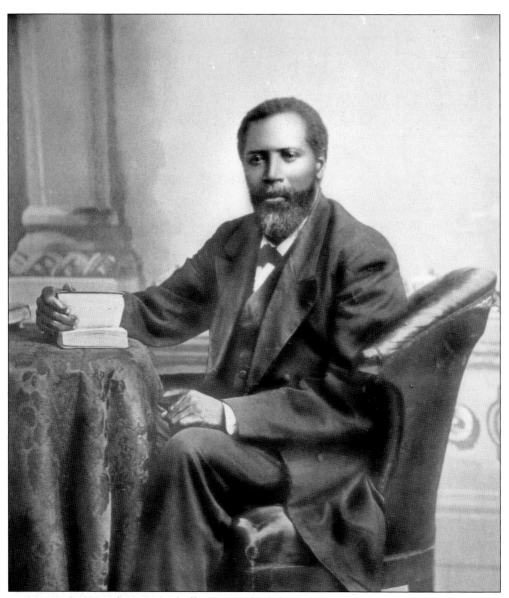

As a young man, Madison Campbell converted to Christianity and was encouraged to preach by ministers and other people who heard him speak at open meetings. He served as pastor of the United Baptist Church in Richmond for over 35 years. Church history records show that over 7,000 people, black and white, were present in 1859 when he baptized 59 candidates. During the Civil War, Reverend Campbell and his wife earned money keeping house for the government clerks in Nicholasville, near Camp Nelson (Jessamine County). Returning to Richmond after the war, they bought a home on B Street and raised 14 children. Working closely with deacon David Tribble, Reverend Campbell walked, rode horseback or buggy, and traveled by trains to help establish churches at New Liberty in Bobtown (1866), Kirksville, and Otter Creek among other places. (Courtesy Richmond First Baptist.)

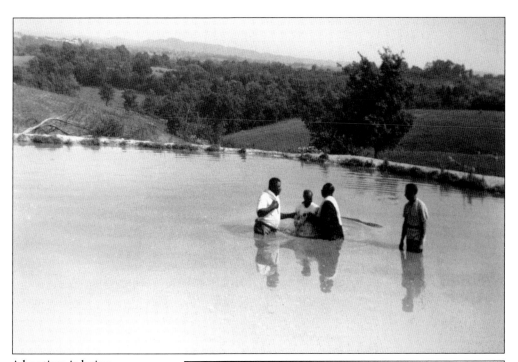

A baptism is being conducted by Rev. Curin Deatherage, pictured here in a robe, at the pond on Four Mile Road in Richmond during the 1940s. The original photograph was taken by a young Paul Ferrell. (Courtesy Paul and Ruth Ferrell.)

Rev. J. Welby Broaddus was the son of Rev. Thomas H. and Elizabeth Ballew Broaddus. A 1908 graduate of Richmond High School, he was called to pastor the First Baptist Church in Richmond. He also served as pastor of Baptist churches in Frankfort and in Dayton, Ohio. (Courtesy First Baptist Richmond.)

121

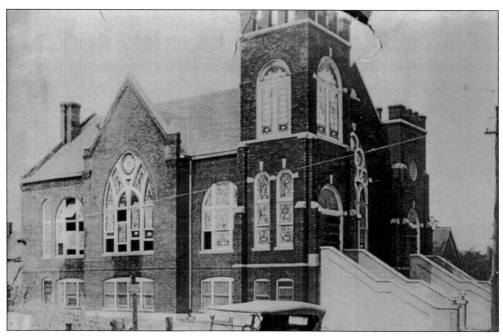

Located on the corner of Frances and Collins Streets, First Baptist Church in Richmond was once known as United Baptist. This picture of the church may have been taken around 1930. Shown below are some of the United Baptist members. The United Baptist membership grew from 173 members in 1858 to 500 in 1873, which overcrowded the log church. Members agreed to tear down the old church and build a new one. In addition to raising money for construction, they opened a brickyard to make the bricks they would need. An association of Baptist churches was organized, the Mount Pleasant District Association, with Reverend Campbell elected as the first moderator. One goal of the district association was support of a college for training ministers—Simmons University in Louisville (Jefferson County). (Courtesy Paul and Ruth Ferrell.)

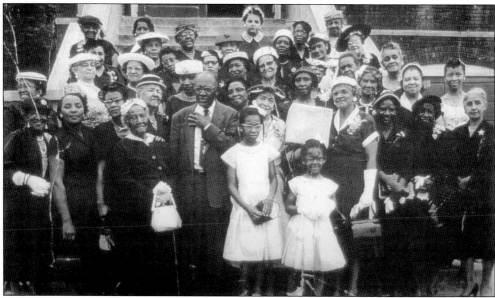

Nine

RECONCILIATION

In 1950, Kentucky's legislature amended the Day Law, which permitted interracial education at public and private institutions of higher education. Elizabeth Ballard (left), whose family had helped settle Berea, was selected to reintegrate Berea College. William Ballew (right) of Richmond was also admitted. A third student, Jessie Reasor Zander, transferred from Tennessee, and in two years, she became the first African American student to graduate from Berea College after the Day Law. (Courtesy Elizabeth Denney.)

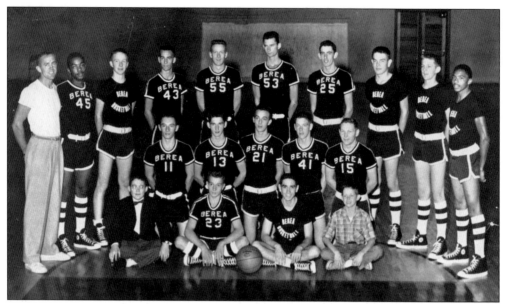

Outlawing segregation restored local opportunities for interracial school activities. Members of the 1957–1958 Berea High School basketball team are, from left to right, (first row) Wayne Wheeler, Bill Watson, Bobby Gibbs, and Tim Pennington; (second row) Bobby Johnson, Robert "Bobby" Himes, Kenny Pigg, Carl Hammond, and Conley Broadus; (third row) Coach Mitchell, Charlie White, Money Coz, Alan Cruse, Kenneth Spencer, Boyd Williams, Clayton Gabbard, Delbert Crutcher, William Ray Finnell, and Gerald Hinton. (Courtesy Bobby Himes.)

Reverend Fee's racially interspersed residential neighborhoods resumed somewhat through public housing. Berea Municipal Housing Commission members breaking ground near the Glade Church monument to Clay and Fee are, from left to right, Bentley Cummings, Betty Hays, Mayor C. C. Hensley, Frank Farmer, Melvin Higgins, ? Dillion, unidentified, Jim Buck Morgan, unidentified, Harold Ray, Lawson Hamilton, Maurice Hammond, and Dean Warren Lambert. Later an African American was appointed to the commission. (Courtesy Melvin Higgins.)

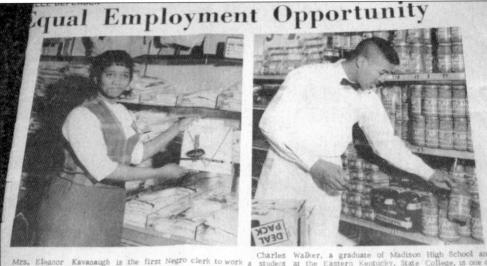

qual Employment Opportunity

Mrs. Eleanor Kavanaugh is the first Negro clerk to work at the J.C. Penny Company.

Charles Walker, a graduate of Madison High School and a student at the Eastern Kentucky State College, is one of the first Negroes to be employed by the A&P Store in Richmond, Kentucky.

Two white-owned businesses started changing their hiring practices to promote economic opportunity. In Richmond's early-20th-century history, black-owned businesses thrived. African Americans could boast of five tailor shops, two shoe repair shops, a blacksmith shop, two grocery stores, a hospital with three black physicians, two dentists, a used furniture store, two black cab companies, restaurants, beauty salons, and black morticians. (Courtesy Ferrell and RHS Alumni.)

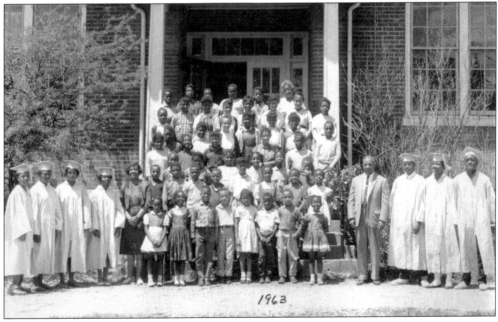

This 1963 photograph of the entire student enrollment for the Middletown Consolidated School marked its last year in operation. Under the Madison County Board of Education's racial integration plans, students attending all-black schools were reassigned to desegregate all-white schools. In Richmond, Richmond High School's last year of operation was 1956. (Courtesy Robert Blythe collection.)

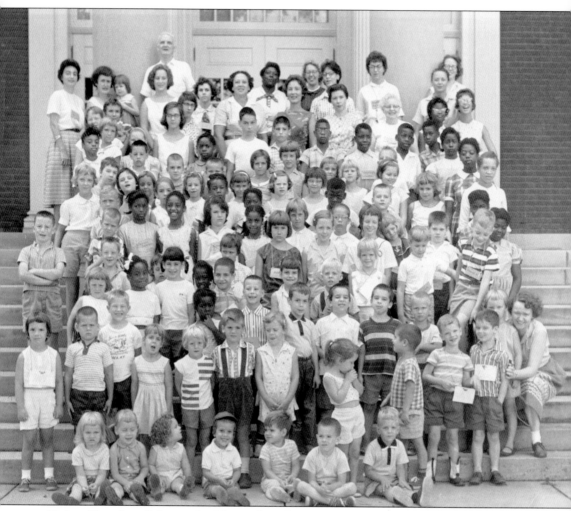

Union Church collaborated with nearby African American churches in Middletown and Farristown to conduct an interracial Vacation Bible School in the early 1960s. The pastor of Union Church was Rev. Scotty Cowan, seen standing in the back row. In Reverend Fee's plan for a racially interspersed community, children would grow up learning to treat each other as equals in a practical application of impartial love. (Courtesy Berea College.)

INDEX

ACROSS AMERICA, PEOPLE ARE DISCOVERING
SOMETHING WONDERFUL. *THEIR HERITAGE.*

Arcadia Publishing is the leading local history publisher in the United States. With more than 3,000 titles in print and hundreds of new titles released every year, Arcadia has extensive specialized experience chronicling the history of communities and celebrating America's hidden stories, bringing to life the people, places, and events from the past. To discover the history of other communities across the nation, please visit:

www.arcadiapublishing.com

Customized search tools allow you to find regional history books about the town where you grew up, the cities where your friends and family live, the town where your parents met, or even that retirement spot you've been dreaming about.